779.994183

MAN ON THE BRIDGE

MORE PHOTOS BY
ARTHUR FIELDS

Arthur Fields stood on O'Connell Bridge almost every day from the 1930s until 1988 and took an estimated 182,500 photos of passers-by. Before an era of smartphones, he provided a vital service, taking photographs of couples on first dates, people up in Dublin for the day, happy parents with newborn children, matchgoers and even some celebrities. His photographs bear witness to a changing cityscape, fashion, lifestyle, social habits and even camera technology. The result is a window onto a different era, a time when photographs were taken to be cherished.

Ciarán Deeney and **David Clarke** have worked together for over ten years producing documentary, drama and multi-platform projects including Man on Bridge, a national photograph collection campaign.

Facebook.com/manonbridge
Twitter: @ManOnBridgeDoc

www. MAN ON BRIDGE .ie

Man on Bridge Project Partners

MAN ON THE BRIDGE

MORE PHOTOS BY ARTHUR FIELDS

www. MAN ON BRIDGE .IE

COMPILED BY CIARÁN DEENEY & DAVID CLARKE

The Collins Press

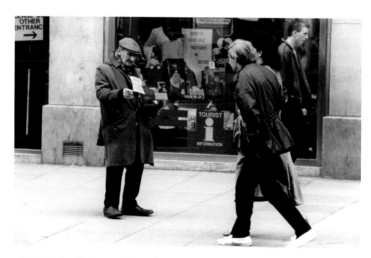

1983 'Arthur Fields on O'Connell Street near the end of his career.' *Paul Freeney*

INTRODUCTION

Launched in 2014, the Man on Bridge project was a campaign to collect the photos and tell the story of Arthur Fields, a street photographer who stood on Dublin's O'Connell Bridge and Street from the 1930s to the 1980s. During the campaign, ordinary people were asked to dig out photos in their possession taken by street photographers on Dublin's main thoroughfare. What started out as a website collecting the photographs quickly grew into a book, an exhibition and a TV documentary. This final book, published in 2017, marks the end of the project. An archive of almost 6,000 photographs has been crowd-sourced from all across Ireland and abroad and this book is a final selection from the collection.

In starting the project, we had one goal. No matter how big or how small, we wanted to emphasise the role that everyone can play in authoring social history. Walking down a street is an act of history-making in itself; being photographed is an act of documentation; and submitting your photograph to a project like this is an act of archiving.

With no surviving negatives, these street photographs were scattered across the globe in family albums. By bringing them together through the Man on Bridge project, we have, we hope, managed to create a moment of solidarity. A unique archive of Dublin street life has been created as a result of thousands of people coming together and sending in their photographs and stories. This final book celebrates these individual contributions. Throughout this book, we also use the rich archive to reveal trends throughout the period of Arthur Fields' working life. From changing night-life, to the modernisation of prams, to a growth in youth culture, Arthur's camera captured social history on the move and hopefully this book captures that.

Of course, this project wouldn't exist without Arthur, his work ethic and, indeed, the kindness of his family in sharing the legendary story of Arthur, a man who took photographs for payment on O'Connell Bridge and Street for over fifty years. That story became the hook that encouraged people to contribute; however, behind that narrative, the campaign was an umbrella project that accepted all street photos taken by him and, indeed, the many other people who worked as street photographers. Now, at the end of the project, we express deep gratitude to Arthur and his colleagues, who consciously and unconsciously captured so much.

Looking back at the project, we are personally delighted to have played a role in creating an archive of twentieth-century life in Ireland, primarily in the role of facilitators. Ultimately it's an archive that was created by the actions of thousands of ordinary people, and one that will hopefully be enjoyed by future generations and pored over by social historians, and will remind people of a time when photographs really were cherished.

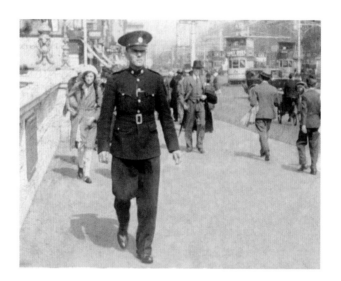

1930 'Hugh McCabe from Balbriggan, born in Latton, County Monaghan. In 1915, at the age of 22, Hugh was one of the many young Irishmen who volunteered to join the British Army during the First World War. He enlisted at Mullingar and was first posted to the Leinster Regiment. He also served with the Royal Inniskilling Fusiliers. Hugh was the recipient of three wound stripes, having been injured in the field of battle on three separate occasions, and was awarded several medals for gallantry. Having witnessed the horror of trench warfare, Hugh was declared "no longer fit for war service" and was discharged from the army in 1919. Following his discharge from the army, Hugh served in the Royal Irish Constabulary (RIC). He spent some time as a bodyguard to the famous Irish republican politician, Harry Boland. The RIC was disbanded in 1922 and was replaced by An Garda Síochána and Hugh stayed in the Gardaí until his retirement in 1950.' *Anne Toner*

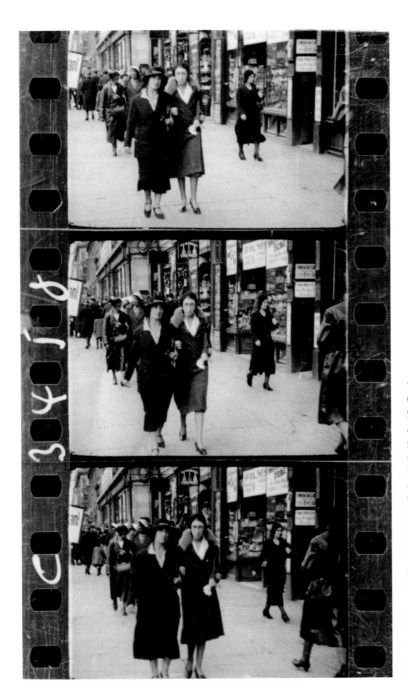

1932 'My mother, Dorothy Wellspring, and her mother, Catherine Wellspring, "walking" along O'Connell Street, September 1932. This set of three photos, taken one after another, formed a postcard which would have been subsequently separated into three pieces and possibly sent to different people. In 1910 Catherine married Private Owen Wellspring, 1st Battalion Irish Guards. Owen left the army in 1912, but when the First World War broke out he rejoined the Irish Guards as a corporal. In September 1914 he was sent to Caterham Barracks in Surrey, England, where he trained soldiers for the Western Front and rose to the rank of sergeant. Catherine joined him in Caterham in 1915 and their daughter, Dorothy, was born there in May 1916. Owen was sent to the Western Front in June 1916 and was killed on 2 August 1917 in Flanders at the Battle of Passchendaele (the Third Battle of Ypres) during the main assault, which had begun at the end of July. A dogged struggle against determined German opposition and the rapidly deteriorating weather ended in November with the capture of Passchendaele Ridge.' *Bob Smyth*

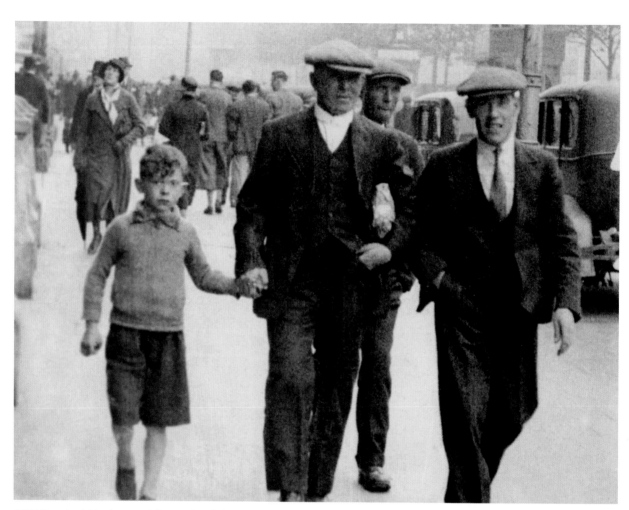

1934 'I received this photograph from my late father, Daniel Ryan. It depicts some members of his family. Before he passed he named the people in the photo. They are: Jim Kealy and Mick Kealy (my granduncles); Paddy Bourke (the taxi driver); and a young Daniel Kealy (Jim Kealy's son). The photograph was taken on a day out to visit Jim's daughter, Margaret (Maggie), who was being cared for in Cappagh Hospital, County Dublin. I can only presume the parcel was a present for Margaret from her family. Margaret later died at the age of fourteen.' *Ann Feehan*

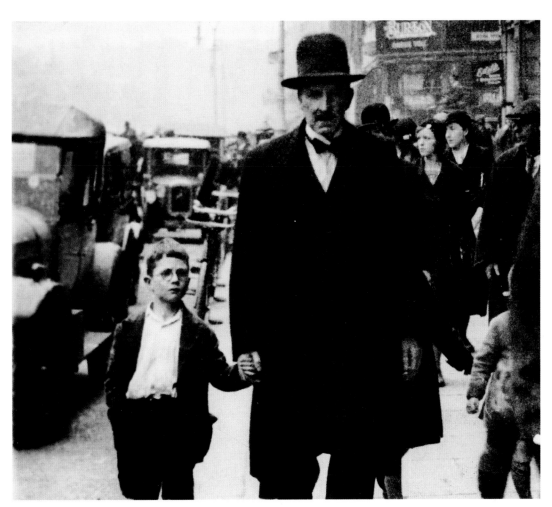

1934 'My grandfather, Michael Healy, and my father, also called Michael, aged six. The older Michael was born in Mayo in 1874. He was a member of the Royal Irish Constabulary (RIC) from 1895 until disbandment in 1922, serving mainly in Sligo and finishing with the rank of sergeant. He spent some time in London when he left the RIC but came back to Ireland and was married in Dublin in 1925. He had three children; my father Michael was the middle child and the only boy.' *John Healy*

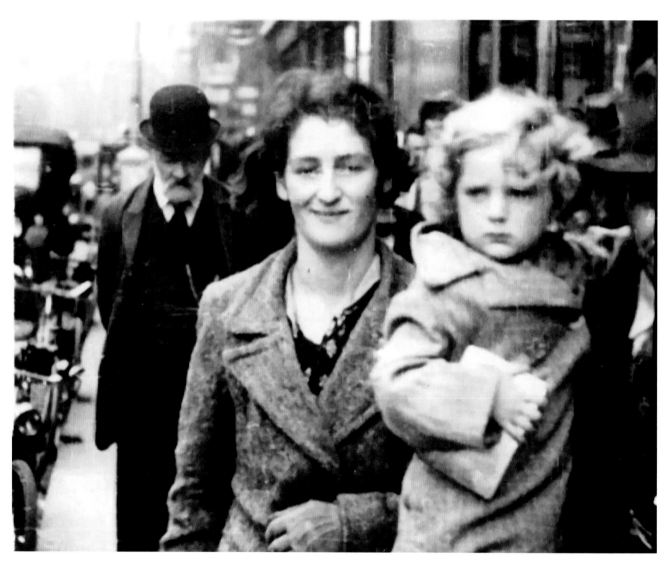

1935 'My ma, Jin Conway from Lucan, and my eldest brother, John. At this point in her life, my mother only had one child, but she'd go on to have another eight. It's a fantastic photograph of street life from the time and I love the man in the bowler hat in the background. I believe the man holding my brother up was a lodger in our house, an Italian chef called Mario who worked in the Spa Hotel, Lucan.' *Brian Conway*

1935 'My grandfather, William (Willie, Liam) Langley, who was born in Sydney, Australia in 1888. His father, originally from Athenry, had left Ireland to work on the "diggin's" in Queensland. In 1892, he and his wife, along with Liam, made the arduous journey back to Ireland, arriving back with little or nothing following the theft of most of their belongings in Southampton en route. The family settled in Tuam, County Galway, where Liam attended the Presentation Convent and then the local Christian Brothers school. He was very interested in the Irish language, history and folklore. As a member of the Gaelic League he came into contact with many important figures of the era. In 1911 Liam started a branch of Na Fianna Éireann in Tuam, later setting up a unit of the Irish Volunteers in the town. Liam was also a leading member of the IRB in North Galway. He organised the Volunteers in Tuam to come out during Easter Week 1916, and continued the fight further south in Galway, in Athenry, with Liam Mellows. After being arrested in Tuam, Liam was incarcerated in a number of prisons, including Richmond Barracks, Dublin; Frongoch, Wales; and finally Reading, England, where the main leaders and men considered extremists were held. Following his release in December 1916, Liam relocated to Dublin, where he continued his involvement with Na Fianna and the Volunteers. Liam was involved in the War of Independence, and worked closely with Michael Collins in the newly established Department of Finance. Liam took the anti-Treaty side during the Civil War and was captured in August 1922. He was again imprisoned, this time in Mountjoy Jail and Newbridge Camp, and released in December 1923. Liam married Molly Kelly in Fairview church in 1927, and they had six children. In 1933 Liam was reinstated in his old job in the Department of Finance, where he worked until retirement.' *Eimear Cremen*

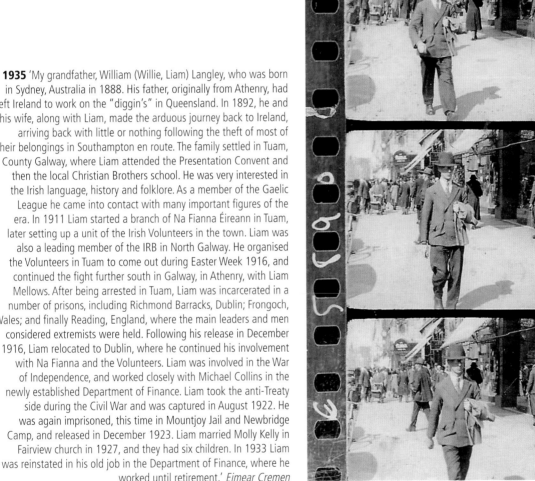

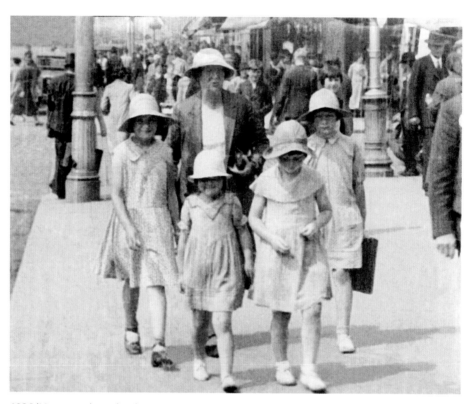

1936 'My maternal grandmother, Marie Lloyd (née Keyes) and her four daughters. They are, from left to right: my mother, Joan (Egan); Marie (Brady); Phyllis (Lyons); and Noreen (Finn). They are on their way to feed the ducks in St Stephen's Green. Joan and Phyllis are still around to feed the ducks.' *Deirdre Ekstrom*

1938 'My great grandmother Catherine Collins (née Dowling). She moved to Lucan from Wicklow in the 1890s. She had thirteen children and fostered many more. I don't know why she looked after so many children, but she was an amazing woman.' *Louise Maguire*

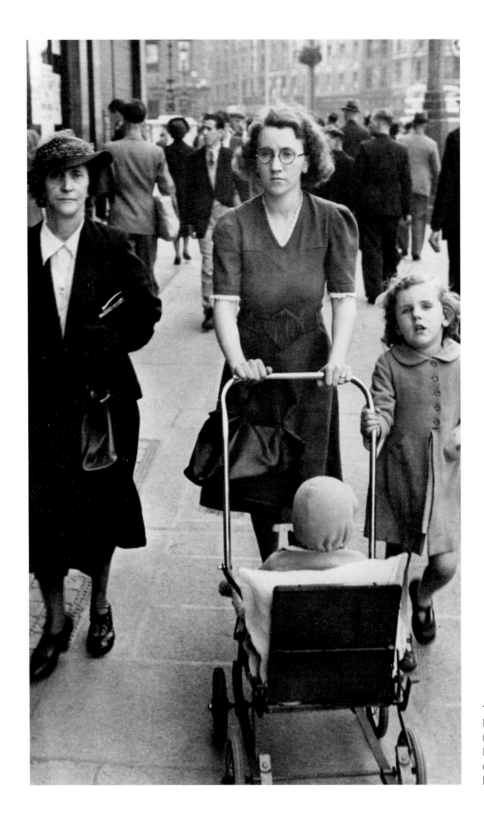

1939 'My grandmother Helena Nugent, my mother, Jennie (Helena) Finlay and my sister, Patricia, who is about four years old. I am in the pram – I was born in 1938.' *Paul Finlay*

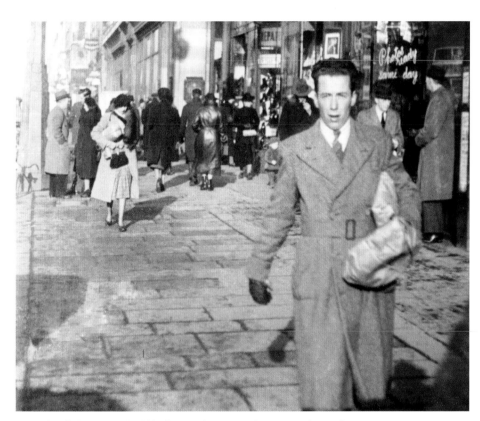

1939 'My father, Patrick (Paddy) Allen, aged 21 years, shopping in O'Connell Street on 25 January 1939. Paddy hailed from Railway Street in Navan and in 1939 was a student at St Patrick's Teacher Training College, Drumcondra.' *Lydia Varley*

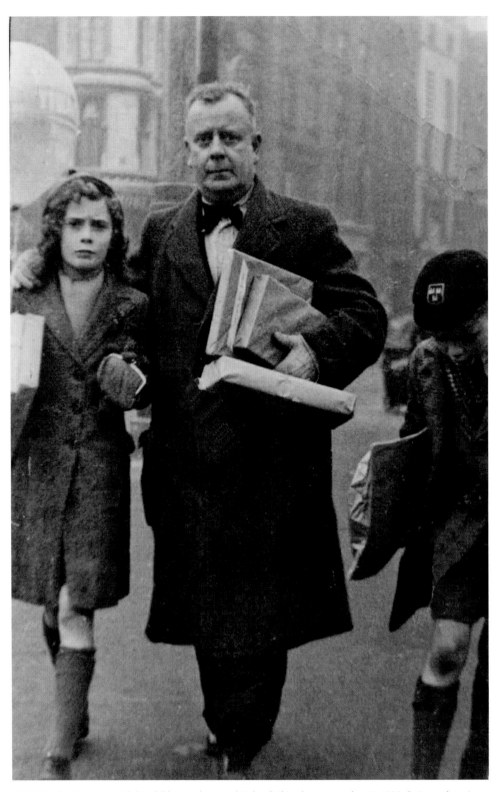

1939 'Gordon Brewster with his children, Dolores and Richard. This photo was taken in 1939 during a shopping expedition in town. Gordon was arts editor and chief cartoonist with Independent Newspapers. He was also a regular customer of my mother's shop, The Gem in Howth, and he died suddenly in the shop on Bloomsday, 16 June 1946. His death in my mother's shop sparked an interest in me and I did some research into his life, which led to his family giving me this photograph. He was a very talented and somewhat forgotten artist; the National Library of Ireland has recently acquired a set of some 500 of his cartoon originals.' *Pól Ó Duibhir*

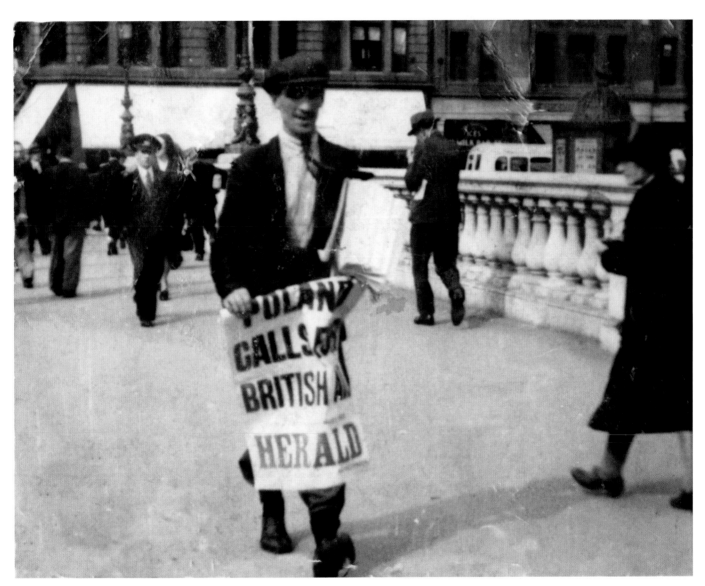

1939 'The man selling the newspaper is Joseph Dalton, my grandfather, who was from Ringsend and lived all his life there. He sold newspapers on Kildare Street until the age of 81. This photo was taken the day the Second World War started (1 September 1939). The week after this photograph, my grandfather enlisted with the British Army and he was ultimately involved in the liberation of Bergen-Belsen concentration camp. Eight people from the Ringsend area left to join the British Army, but only two returned. For the rest of his life, my grandfather didn't know why he was chosen to live and others didn't.' *Charles O'Callaghan*

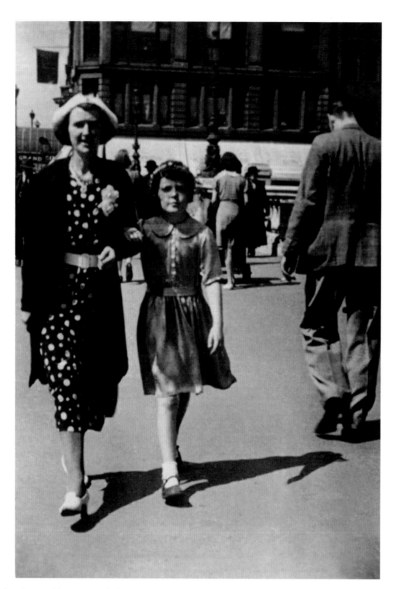

1939 'My grandmother Kathleen Kennedy (née Hessman) and her eldest daughter, Kathleen (Lena). My grandmother was born in Ratoath, County Meath, in 1900 and came to work in Dublin when she was still very young. She married William Kennedy in1928 in the Church of the Most Holy Trinity, Ratoath, County Meath. My grandfather was an army cook and they lived at 8c block, in the Arbour Hill married quarters. They had two other children, Joan (my mother) and John. Lena was born in 1930, Joan in 1931 and John in 1933. All are now deceased. This photo brings back lovely memories of my grandmother. She always loved to dress up for occasions and this photo shows her in great style. My aunt's dress is very pretty and a fitting accompaniment to my grandmother's outfit. There is a determination in their step as they walk along O'Connell Bridge. Where were they were going on that grand day in 1939? For a stroll in the sunshine? Maybe they had visited the Grand Cinema, shown in the background?

'My aunt left for Canada on the *Aquitania*, departing from Southampton on 25 October 1949, aged nineteen. Her occupation was listed as "machinist". She settled in Halifax, Nova Scotia and married a naval officer, with whom she raised three children. Lena made several trips home to Ireland, but her heart was always in Canada. She died in 2016 and is buried in Canada.

'When my sister and I were growing up in Dublin in the 1960s and 1970s, we loved to visit my grandmother and listen to stories about her childhood and her early days working in Dublin. Even today, walking around Dublin and crossing O'Connell Bridge brings back happy memories of the times we spent in her company. As adults, my sister and I were fortunate that she lived to be present at big moments in our lives.' *Catherine Maguire*

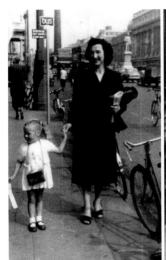
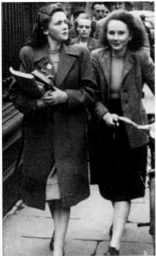
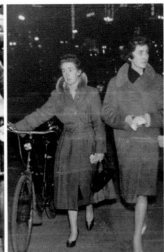
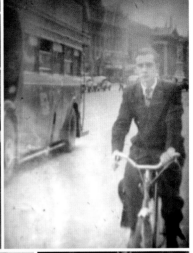
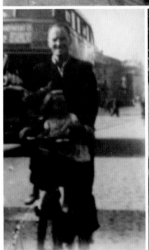
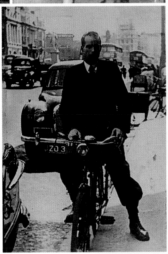
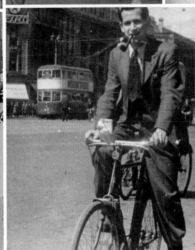
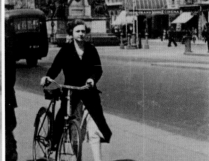

BICYCLES

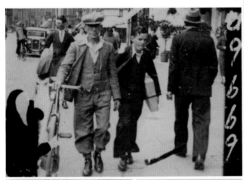
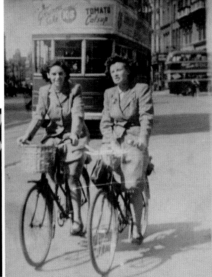
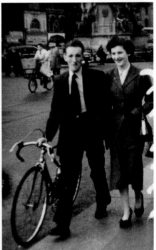
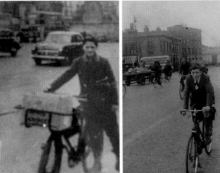
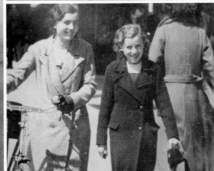
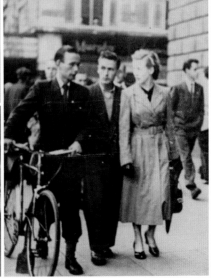

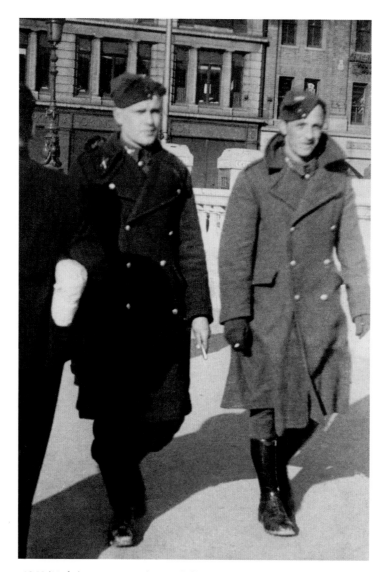

1940 'My father, James Joseph Biggs (left), who was in the Irish Volunteer Force under Éamon de Valera, 1939–46. The Volunteer Force was set up during the Emergency as a national defence force. My father was a champion swimmer, boxer and gymnast and was used in advertising to encourage others to join.'
Maggie Biggs

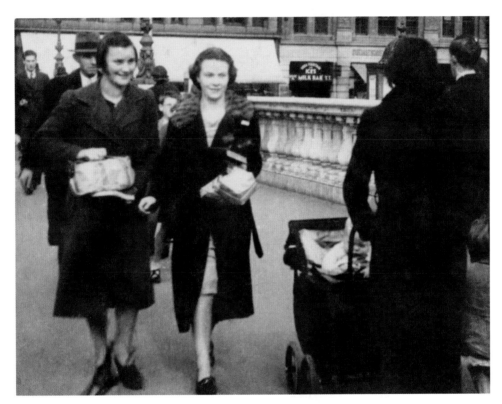

1940 'Maria Blackmore (left) and my aunt Ivy Finlay, who at that time was living just off Sandymount Green with her aunt. Ivy's mother had died in 1937 and her father and brother both emigrated to England to do war work. While she was living with her aunt, she developed TB and spent time in Newcastle Sanitorium, where she met Harry Bryan, whom she married in 1953. They were unable to have children because of their TB treatments and were barred from adopting because they had had TB. In Ireland at the time, there was a stigma attached to TB, and people were frightened of it. I remember my mum had a special teacup for Ivy that we weren't allowed to use. My aunt attributed her survival to Noel Browne's introduction of streptomycin.' *Deirdre Ennis*

1940 'My great grandfather Leo Byrne (1888–1970) with his two sons. Peter (1933–1957), on the left, died tragically young in a drowning accident. This is one of the very few photos that survive of Peter and one that my grandfather cherished. The other boy is my late grandfather Noel Byrne (1934–2014), and this is the only photo that we have of him as a child. This photo holds many memories, even now, and It has been passed on to Leo's great-great-grandchildren to ensure that the memories, particularly of Peter, are handed down to the next generation.' *Stephen White*

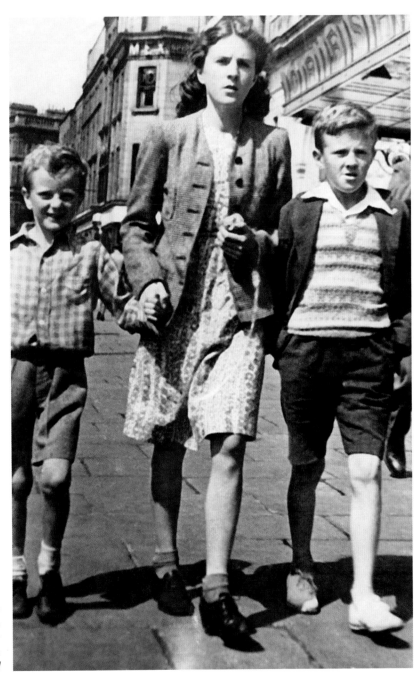

1941 'My mother, Kathleen Garland (née Condon), who was fourteen years old when this photo was taken, on O'Connell Street, with her brothers Eamonn (then eleven) and Sean (aged four). My mother had three brothers, no sisters, and she was close to all three. The two boys in the picture emigrated to the USA in the 1950s and lived there for the rest of their lives. They visited Ireland, but she never went to the States.' *Pat Garland*

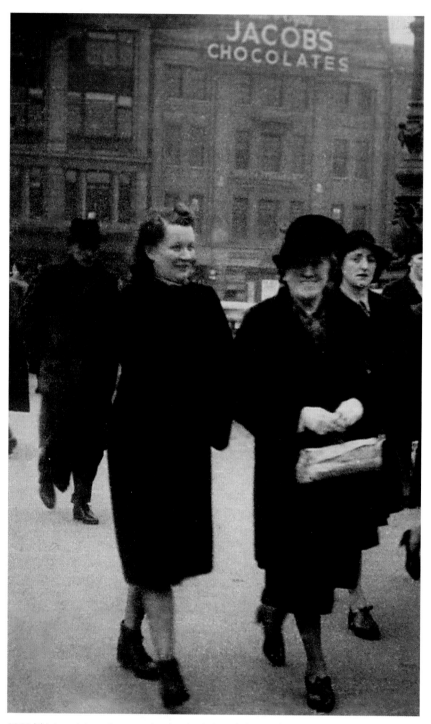

1941 'This is a picture of my grandmother Annie Ryan (née McCabe) (holding parcel) and my aunt Maureen Ryan (later Fortune). It was taken the week before my grandmother went into hospital for a routine operation, during which she died unexpectedly. The parcel contains slippers purchased in preparation for her going into hospital. We believe this is the last picture taken of her.' *Colman Nolan*

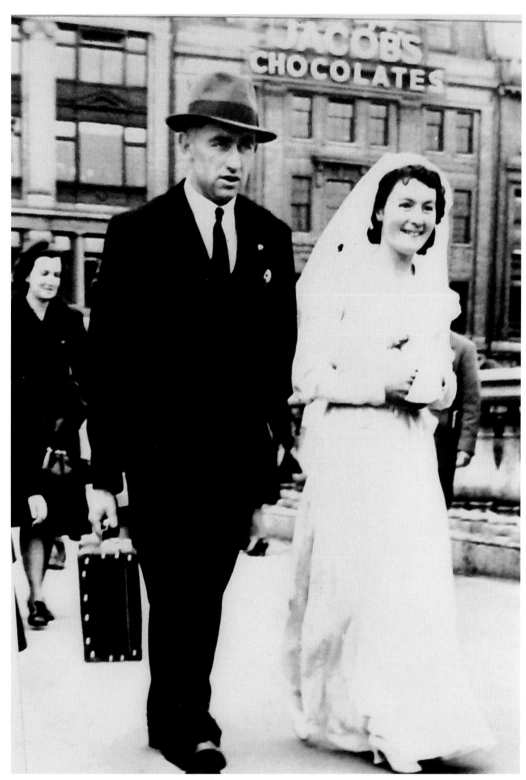

1941 'My parents, Joseph Keena and Catherine Hegarty from Westmeath, on their wedding day, 11 June 1941. They had their wedding breakfast in the Newbury Hotel just beside Mullingar railway station, then they went on the train to Dublin for their honeymoon. They were going across the bridge heading for Bray when they were photographed. My mother had been a nurse in London, but she returned to Ireland because of the bombings over there during the war.' *Enda Keena*

1941 'My aunts – Nessie (left) and Pearl Brown of Dundonald, County Down – photographed during a visit to Dublin in August 1941. Nessie would have been 30 and Pearl 25. My father's family were regular visitors to the Free State. Nessie and Pearl's father, James Brown, was the Northern General Secretary of the Irish Bakers', Confectioners' and Allied Workers' Amalgamated Union. They might have been down with him while he helped plan the development of Four Province house, or they might just have been on a smuggling trip for butter, nylons and cigarettes!' *Stephen Brown*

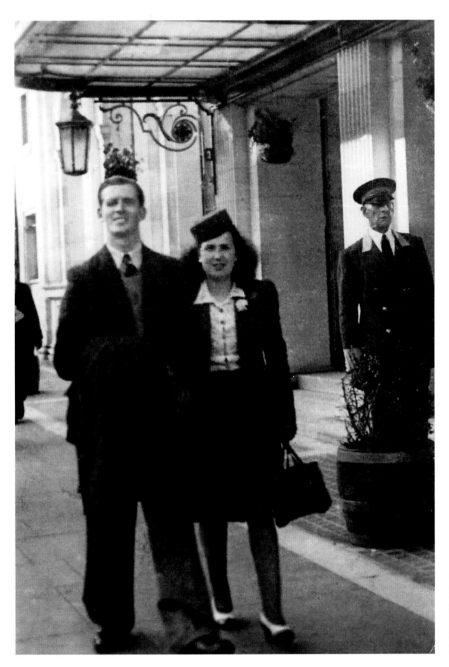

1942 'My parents, Mick and Imelda Maguire (née Kavanagh). They had just got off the bus on Parnell Street and were passing the Gresham Hotel on a summer evening on their way to a dance in the Metropole ballroom.' *Cathal Maguire*

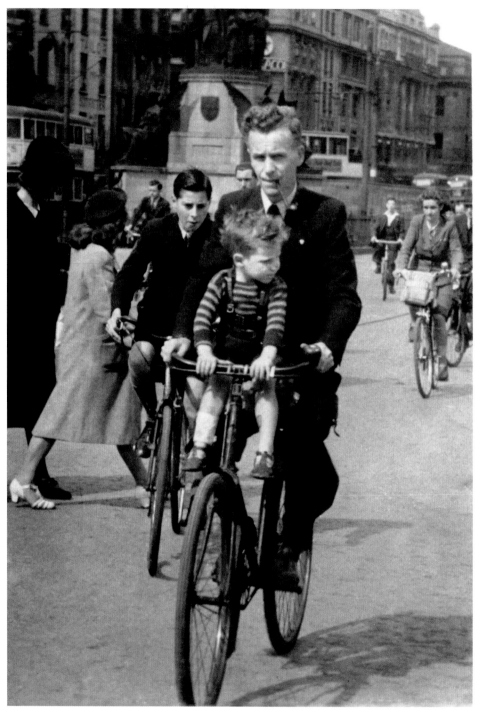

1942 'This is the earliest photograph of my father (Thomas Downes), sitting on the crossbar of his father's (Edward Downes) push bike on O'Connell Bridge. My grandfather Edward was born a twin in 1901. My father, Thomas, was born in June 1938 and he was also a twin, but sadly his twin died at birth. In the photograph, my father is about three years old. They were on their way to the Royal Hospital in Donnybrook to see my grandfather's twin brother, who had Parkinson's disease. My grandfather never went anywhere without his pipe. He was the head porter in Allied Irish Bank on Dame Street, formerly the Munster & Leinster Bank. My father went on to become a porter for the same bank.' *Alan Downes*

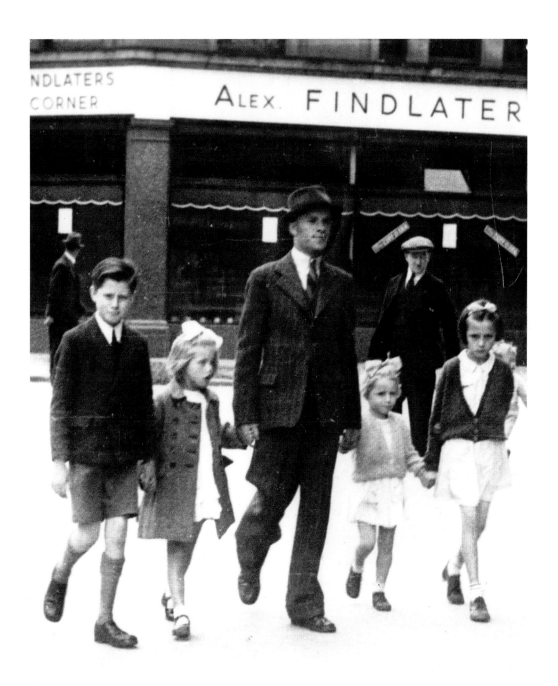

1943 'My father, Leo Tracy, with four of his six children; my brother Arthur, and my sisters Olive, Cora and Margaret. This picture was taken around 1943 or 1944. They were out visiting relations to celebrate my sister Olive's communion. Arthur, then aged thirteen, was at home on a rare visit from St Joseph's School for the Deaf in Cabra. Olive is wearing her confirmation outfit, Cora, aged four, is on my father's left, and Madge, aged nine, on the right. They are all in their Sunday best. This picture has travelled with us from 1950s Dublin to the USA through many years and moves. We have few photos of our parents when they were young, and even fewer of Arthur, who was a boarder at Cabra from the age of five until his late teens and was rarely allowed home. The photograph, along with a Man on the Bridge photo of my mother, Margaret Tracy, with our Aunt Kitty, are family treasures.' *Leo Tracy*

1943 'My father, Peter Clifford, and my sister Betty, formerly of Linenhall Terrace and then Glenbeigh Road, outside the Gresham Hotel around 1943. Peter ran the clothing manufacturing company Callans of Rathmines and Jervis Lane. He was also a long-serving officer of the Amateur League. Betty was the first of seven children and, as you can see from the picture, she was very special to him. No doubt they were having some sweets as a treat on their day out!' *Mary Nolan*

1943 'My grandfather, William D'Art, on the right, with an unknown friend. William was born in 1898 in Lombard Street, Dublin. He was a member of the Boilermakers' Union, and in this photo from about 1943 he is probably coming from a union meeting.'
Ann Walshe (née Morrin)

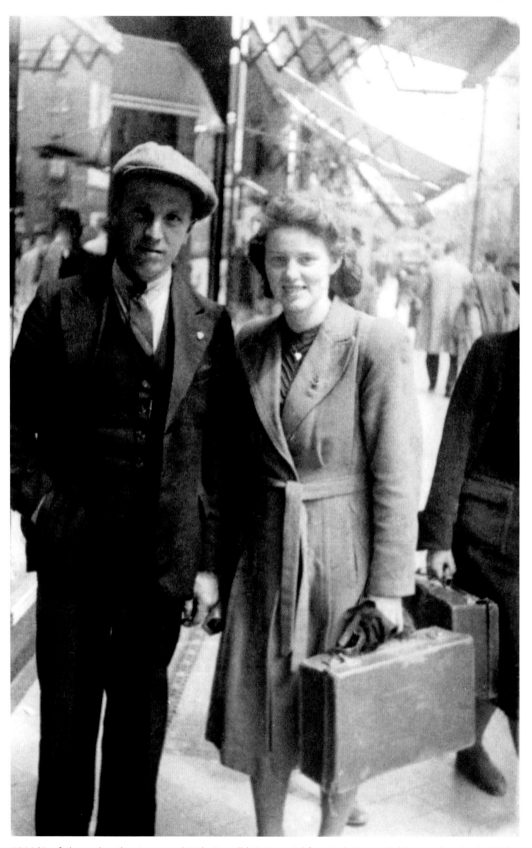

1944 'Our father and mother, Jemmy and Bridie Russell (née Hanratty) from Lusk, County Dublin, out shopping in Dublin city. This photo was taken a year after they married. They had twelve children – nine boys and three girls – and had a long and happy married life. The suitcases people are carrying were used to carry groceries in those days.' *Christy Russell*

1944 'My father, Anthony Farrell, with friends from Castleknock College. Taken on 26 March 1944, the photo is labelled "The day after the cup match". Left to right: B. Hynes, A. Farrell, J. Cribben, S. Smith, S. O'Dwyer, J. Downes.' *Lia Godfrey*

1944 'Kathleen and Michael Moriarty on their honeymoon in Dublin. Kathleen (née Flynn) was from Railway View, Athlone and worked in Gentex. Michael was from Gurranabraher in Cork city. Michael moved to Athlone with the army during the Emergency, where he met Kathleen and fell in love. They were great dancers and regularly went to the Crescent Ballroom in Athlone. Married on 16 December 1944 in St Mary's Church in Athlone, they went on to live a long and happy life together. Michael never lost his contact with Cork and was a regular visitor to the "real capital".'
Cyril Moriarty

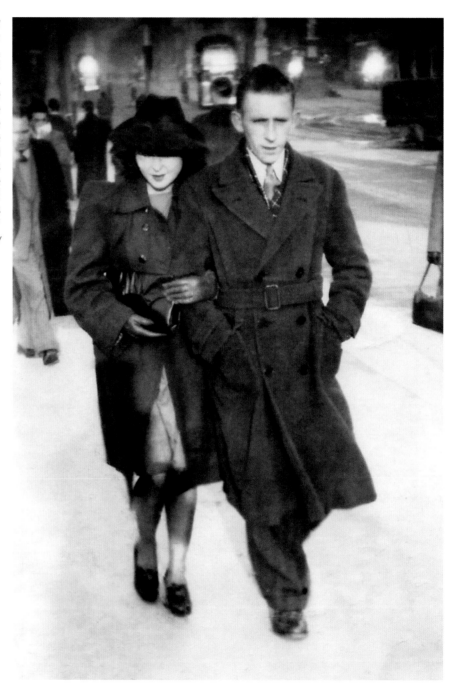

1945 'My mother, Mary Ryan (née Noonan), on the left, and her best friend, Josie Leddin, from Howardstown, Bruree, County Limerick. My mother was a Munster champion cyclist in her day and competed in cross-country bicycle races. The two friends had taken their bicycles to Dublin on the train to visit Mary's sister. In 1945, during the Emergency, trains had more space for bicycles than for humans as cycling was such an important part of life.'
Madge Ryan

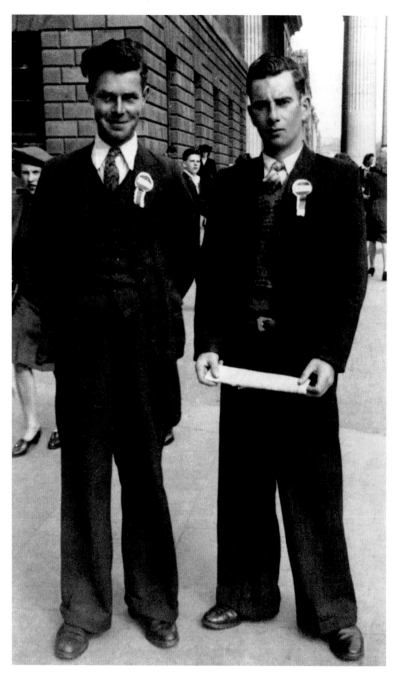

1945 'These two young men from Glengarriff in west Cork were in Dublin on 15 August 1943 for the All-Ireland football semi-final between Cork and Cavan. My father, Paddy O'Shea (on the right) and his friend John O'Mahoney had left Glengarriff the previous year to work in a turf-cutting camp in Kildare. The regime there was pretty frugal during those years of the Emergency, so an outing to Dublin would have been a welcome respite. They went home that evening pretty disappointed as Cork were beaten by Cavan by a single point. Paddy O'Shea joined the RAF two years later and after three years in the Middle East he returned to Glengarriff. John O'Mahoney left for the USA about the same time and settled there.' *Andrew O'Shea*

FUR

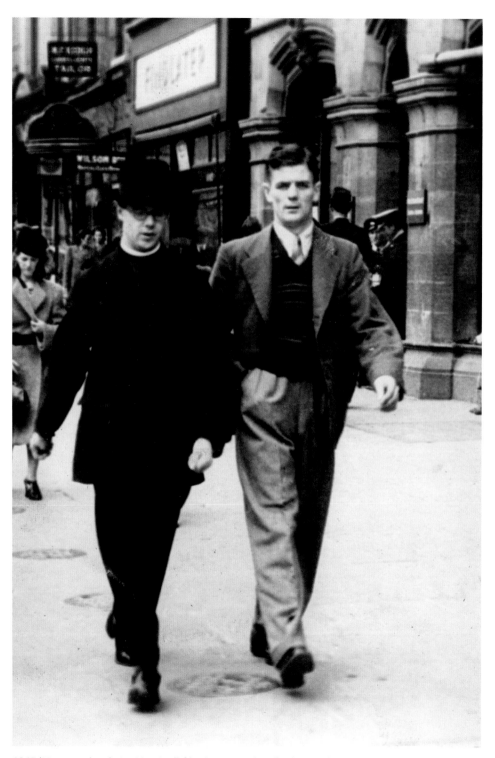

1945 'My paternal uncle Joe Maguire (left), who was studying for the priesthood at the time, and his brother (my father), Tom Maguire, passing Findlaters in O'Connell Street. The photo was taken in the mid-1940s.'
Margaret Sanders

1946 'My dad, Christy Clifford. He came back to Ireland from the UK in 1945 and drove this horse and cart for a number of years before going to work at Tormey Brothers' Auctioneers on Bachelors Walk. My dad knew Arthur Fields well; Arthur took many photos of him in O'Connell Street.' *Pat Clifford*

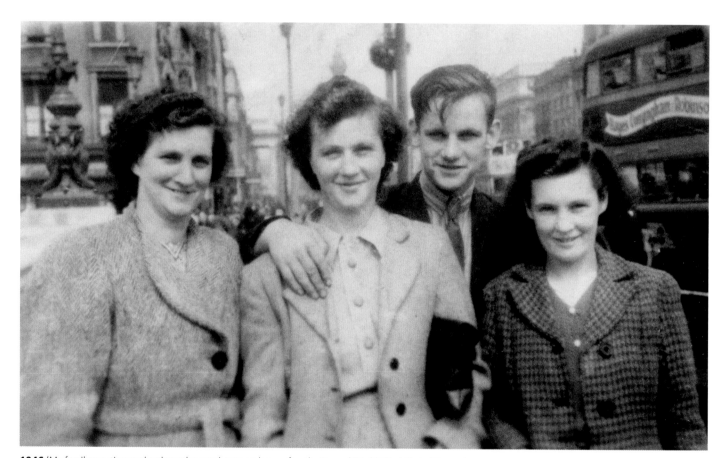

1946 'My family meeting my brother, who was home on leave after the Second World War.' *Kevin Mernagh*

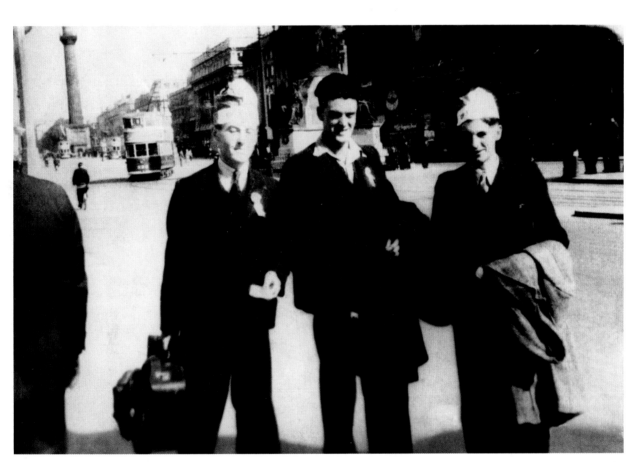

1946 'Left to right: my father, Paddy Brennan, Dinny Regan and Paddy Dunne. They went up to Croke Park to watch Laois play Roscommon in the All-Ireland football semi-final. Roscommon, who were champions in 1943 and 1944, beat Laois that day, 3-5 to 2-6.' *Paddy Brennan*

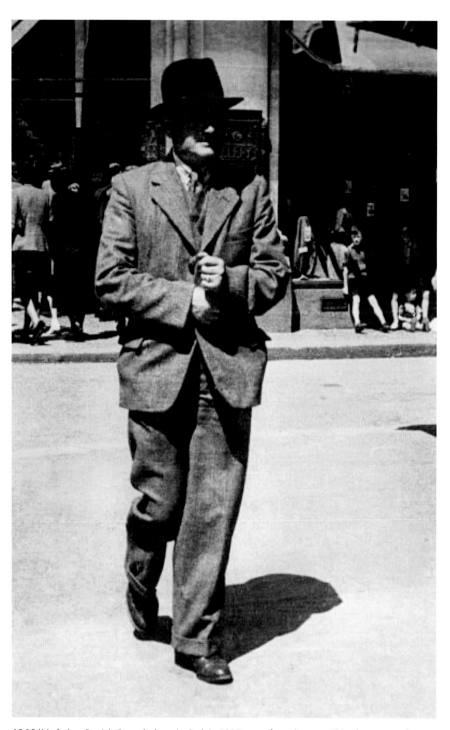

1946 'My father, Patrick Casserly, born in Cork in 1897, son of a policeman. This photo was taken on a trip to Dublin in about 1946. In 1918 he was working in the post office in Bantry when he joined the Volunteers as an intelligence officer during the War of Independence. After independence he joined the new Irish Army as a lieutenant and served in the Railway Protection Repair and Maintenance Corps. He subsequently returned to working in post offices, in Cobh and Kinsale.'
Noel Casserly

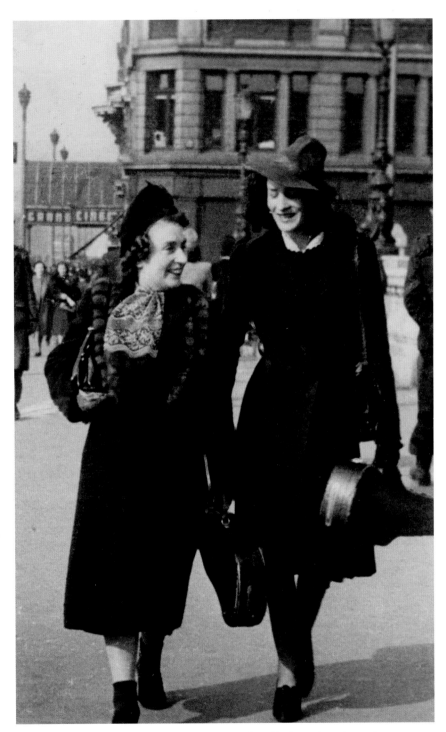

1946 'My aunt, Gertie Lambert (the taller lady), with a friend (unknown). Gertie was from Whitworth Road in Drumcondra. When we were growing up we never heard much about Gertie or any of my father's siblings so we don't have much more information about her. It was only when my daughter was researching the family tree that we discovered that my father's side of the family were Protestants. We grew up Catholic and I think that was one of the reasons for the lack of information – there was a stigma attached to being Protestant in Ireland at that time, unnecessarily so. In our family, it was the done thing to burn photographs when someone died, so we are lucky to have this one; or maybe it was fate.' *Mary Duff*

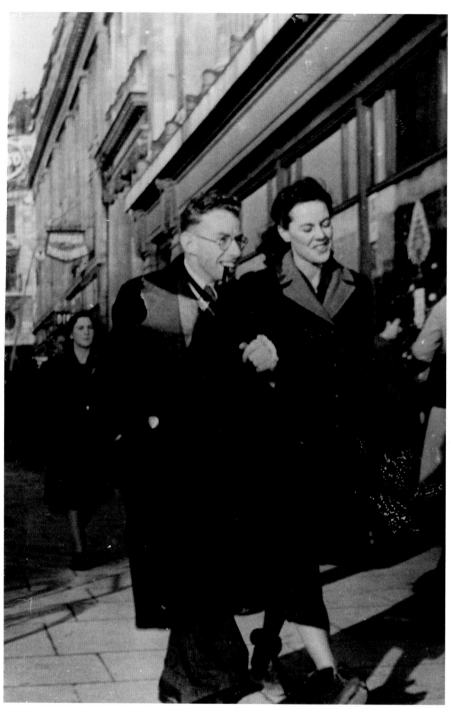

1946 'My parents, Donagh and Nuala MacDonagh. My father was an Irish writer, judge, presenter, broadcaster and playwright. My mother was an occasional actress.' *Niall MacDonagh*

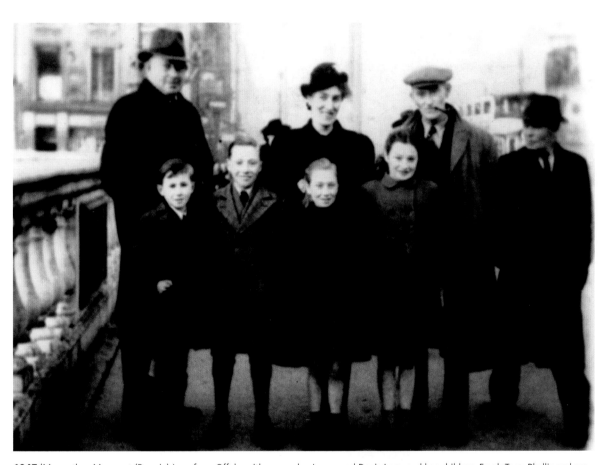

1947 'My mother, Margaret (Bonnie) Lacy from Offaly, with my uncles James and Denis Lacy, and her children, Frank, Tom, Phyllis and me, Mary Louise, on our way to the pantomine in the Gaiety Theatre. We were brought to see the pantomine each year and stayed overnight at the Four Courts Hotel, eagerly awaiting Christmas treats from our parents.' *Mary Louise Lacy*

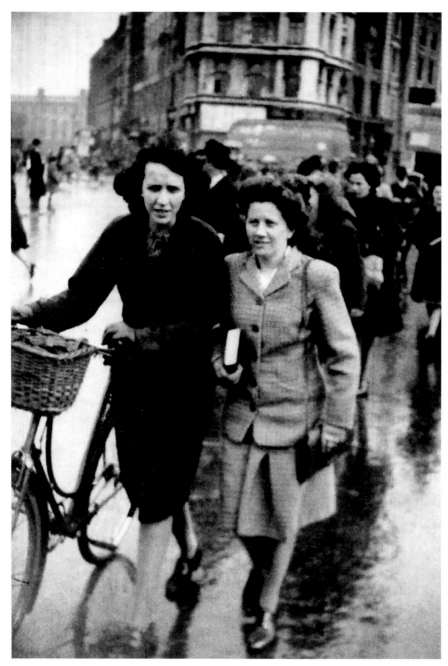

1947 'My mother, Ada Halpin (née Finnegan) on the right, with her friend Maura Dillon in 1947. They're still great friends today.' *Deirdre Munroe*

1947 'This is Arthur Fields' photo of our father, Thomas Fitzgerald, when he visited Dublin in August 1947. He was 22 at the time and in Dublin to complete his medical examination for an emigration visa at the US embassy. The eldest of nine children from a farm in Rabbitboro, Ballinlough, County Roscommon, he was determined to seek out opportunities in America. Two months later, after raising the fare for his passage by digging peat, he sailed for New York City. There, with the help of friends, he settled and found work as a labourer. In time, he met and married our mother, Eileen Reynolds, who had also emigrated to New York – from County Longford. He helped several of his siblings find their way to New York in the years that followed. Dad worked several jobs while attending the City University of New York at night to obtain his engineering degree. He eventually rose to become an executive vice president and the chief building engineer in charge of the historic Williamsburg Savings Bank building in Brooklyn – the one with the distinctive clock tower. He settled the family in Stony Brook on Long Island, where he lived the rest of his life with his lovely wife. They had four children and five grandchildren, and beautiful gardens. He passed away in November 2011 from mesothelioma contracted from asbestos exposure during his years working as a labourer at the Kentile flooring factory in Brooklyn. He loved Ireland and visited his family there regularly until his death. We think he looks quite dapper in this photo and he'd love that it is part of history.'
Deirdre Fitzgerald Cannan, Thomas R. Fitzgerald, Eileen Fitzgerald Leeds, John M. R. Fitzgerald

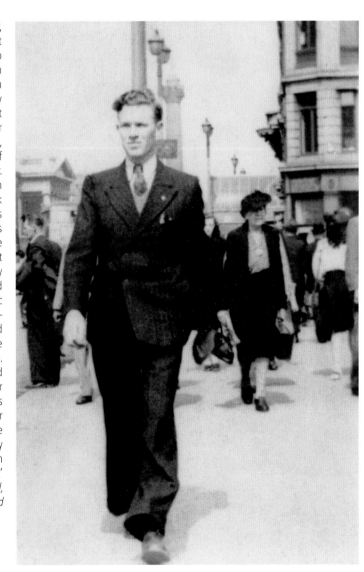

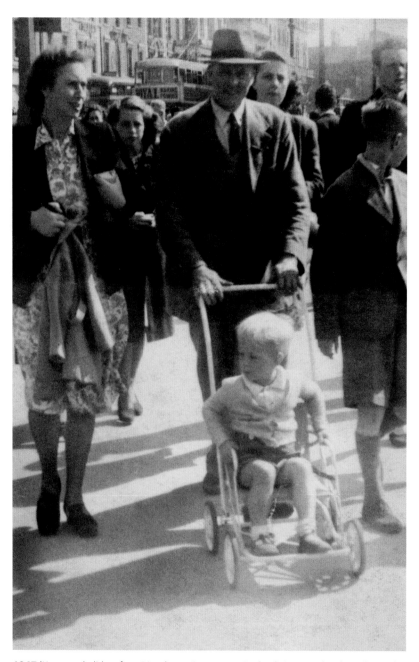

1947 'Home on holidays from Manchester in post-war England. Our grandmother Ellen and grandfather Jack Brennan pushing their youngest son, David. Their other son, John, is walking beside them. My mother, Pat (left), and her sister, Jean, can be seen in the background. The family always holidayed in Ireland and it was on one of those holidays that my mum met my dad.' *Patricia Hughes*

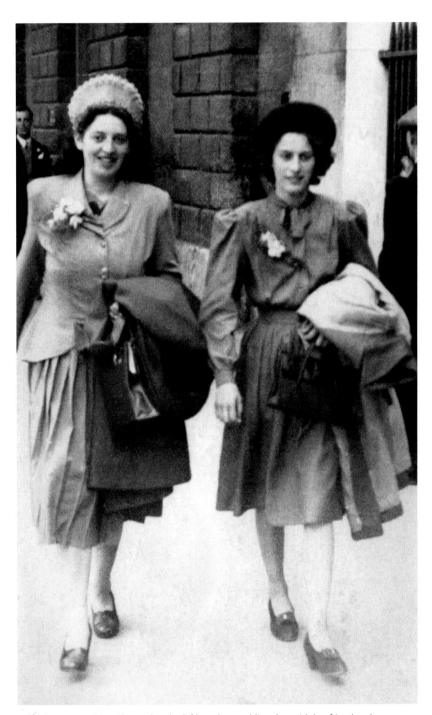

1948 'My granny Mary Thorpe (on the left), on her wedding day, with her friend and bridesmaid, Dympha Phelan. Mary's husband, Harry, can be seen in the background. They were married in St Conleth's Church in Newbridge, County Kildare, and had their wedding breakfast in the Grand Hotel. They travelled to Dublin by car. Mary's outfit was light blue with a navy blue hat and Dymphna's outfit was pink. They spent the day in Dublin and returned to Newbridge later that evening.' *Gill Thorpe*

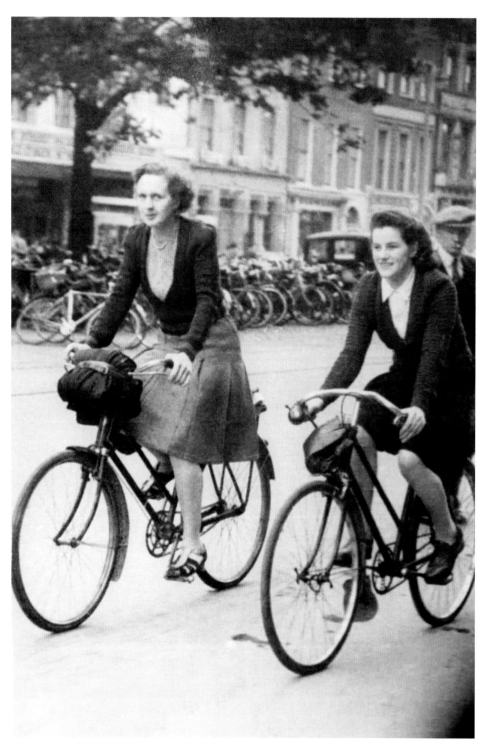

1948 'This photo was taken in the late 1940s. The woman on the right is my aunt Margaret Gorman, originally from Cavan, who is cycling with her friend Peggy Hendrick from Wexford. My aunt worked in a grocery shop in Dublin – Stanley's in Parnell Street – and they were cycling to Howth for a picnic on the day this photo was taken.' *Patricia Cavanagh*

1948 'My mother (who died in 2005) and my six-year-old self. We had arrived from war-torn Germany in April 1947, but already I look a proper little Irish schoolboy. My father was killed on the Russian Front in 1941, before I was born. My mother had a brother who went to England in the 1920s and joined the British Army during the war, while his brother and brother-in-law (my father) were in the German Army. After the war ended, times were hard in Germany and my uncle persuaded the Irish government – a small branch of his business was in Dublin – to allow my mother and myself to move to Dublin in April 1947.' *Theo Hoppen*

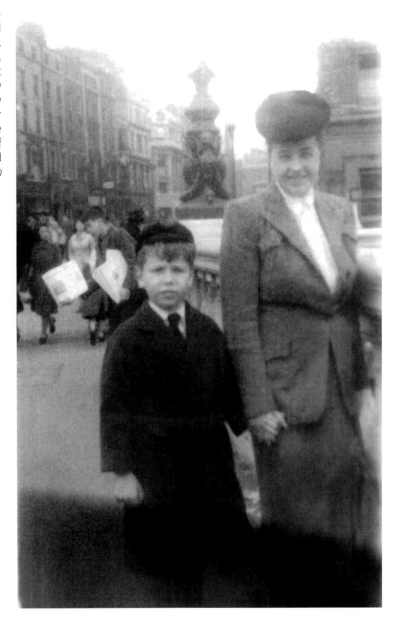

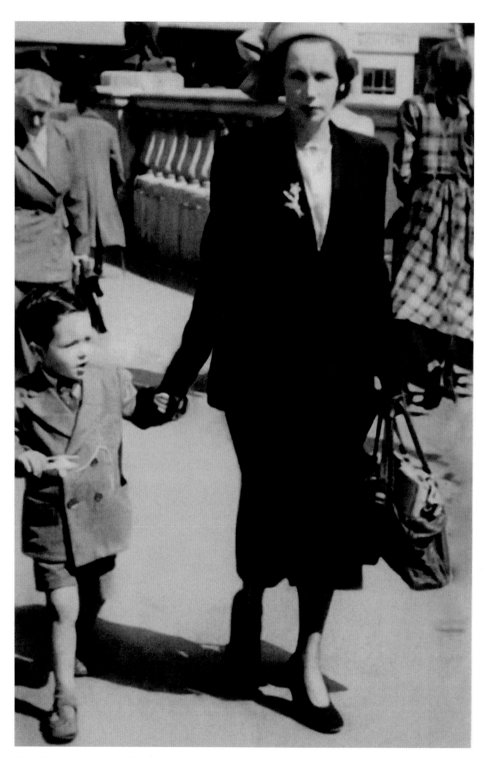

1949 'Me and my mother, Eileen Ryan. She took me into Dublin city on Saturday 25 June 1949 to buy me a present. It was a helicopter and it was purchased in Woolworths on Henry Street. Afterwards she brought me into Cafolla's café for a cake and ice cream and I was so excited about the helicopter that I opened up the box on the floor of the café to play with it. My fifth birthday was 28 June, the following Tuesday.' *Desmond Ryan*

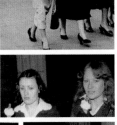
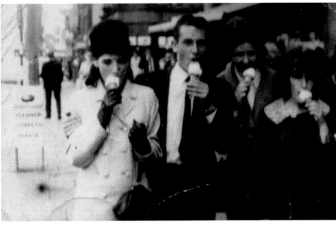

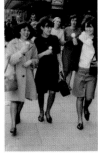
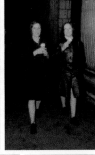
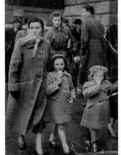
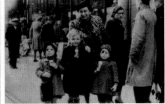

ICE CREAMS

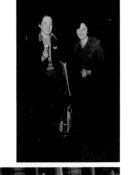
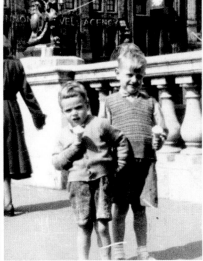
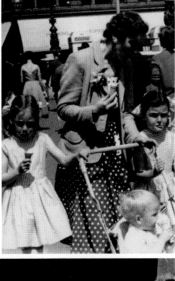
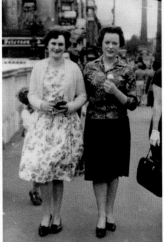
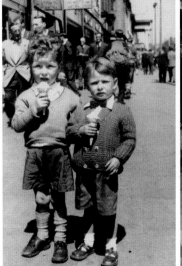
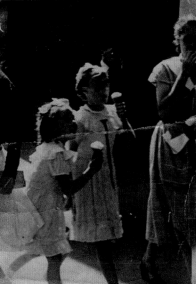
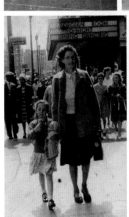
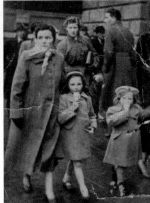

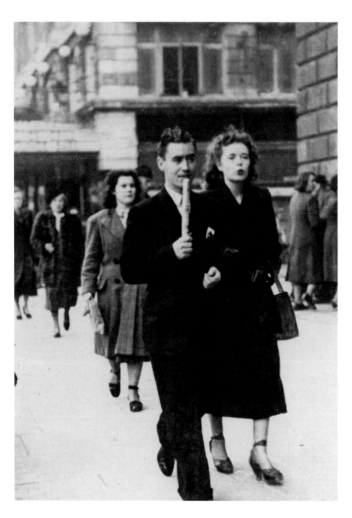

1949 'The young woman in this photo is my Aunt Lena, Kathleen Kennedy. She is accompanied by her cousin and dear friend, Frank McCarthy. The photo was taken in October 1949. I like it as it shows not only Lena and Frank in great style, but the other ladies in the background dressed in beautiful full-length coats and high-heeled shoes. Frank's smart suit, with pocket handkerchief, shirt and tie, and Lena's outfit make them a stylish pair!

'Lena was born in 1930 and was reared in Arbour Hill married quarters with her parents, William and Kathleen, her sister, Joan, and her brother, John. She often recalled that Arbour Hill was a great place to grow up, with great neighbours. As well as being a machinist, Lena was an accomplished Irish dancer and took part in many competitions in the ballrooms of Dublin hotels. She met her future husband at a dance in Dublin in 1948.

'Soon after the photo was taken my aunt left for Canada on board the *Aquitania*, departing from Southampton on 25 October 1949, aged nineteen. On the passenger list, her occupation is listed as "machinist". She settled in Halifax, Nova Scotia, married a naval officer and they raised three children together. Lena made several trips home to Ireland but her heart remained in Canada.

'One can only wonder if Lena told Frank that day of her plans to go to Canada.' *Catherine Maguire*

1949 'My dad, Camillus Murray, cycling home from work. He was a painter and decorator and is sixteen years old in this photograph. He was born and reared in Myra's House on Francis Street. His father was very involved in the St Vincent de Paul and Legion of Mary and was one of the organisers who set up St Camillus's Monastery in Westmeath, hence my dad's name. After Mass on a Sunday afternoon, we'd day-trip the length and breadth of the country.' *Anne Murray*

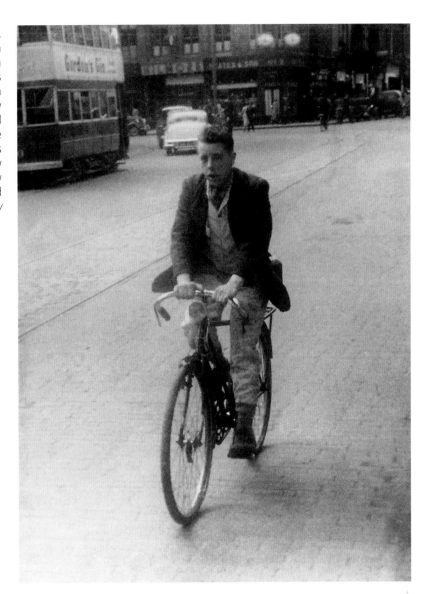

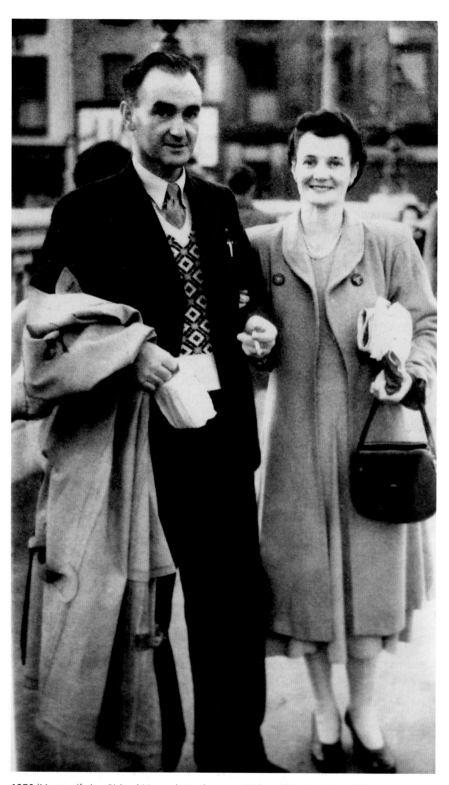

1950 'My grandfather, Richard Mason, better known as Dick, and his sister, Susan Mason, my great-aunt. My grandfather died in 1992, aged around 79, and my aunt died in 2011, aged 95. I found the photo among my aunt's belongings after she died. Although I had never seen the photo before, I knew where it had been taken and by whom.' *Norma Daniel*

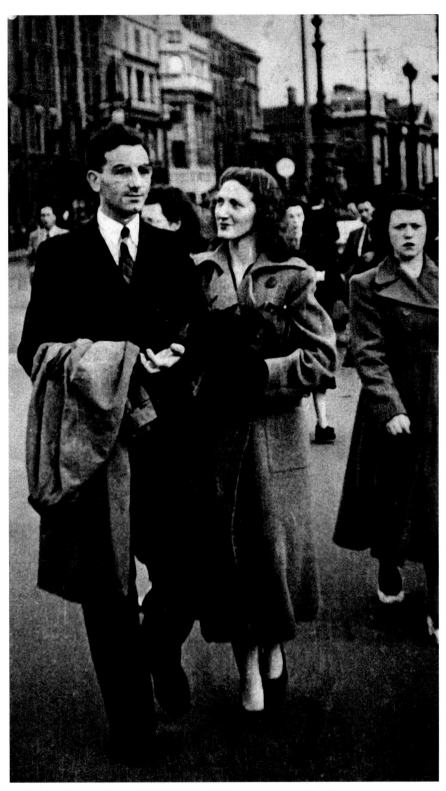

1950 'My father, Larry Whelan, of Rutland Avenue, Crumlin, and my mother, Maureen O'Brien, Glendun Road, Whitehall. At the time my father was working in J & R Fleming's Manufacturing Opticians (he later worked for Yeates & Son, Grafton Street), and my mother worked in Woolworths on Henry Street. In this photo, he is 25 years old and she is 20. They married in 1953. The way my mother is looking up at my father makes it a very romantic image. Both are still alive and both still dote on each other.' *Kieran Whelan*

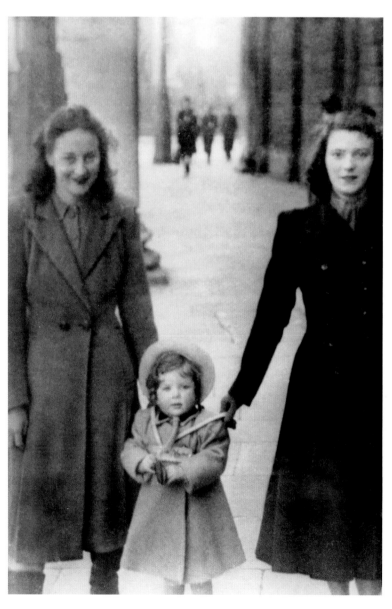

1950 'Albina Quirke from Enniscorthy, County Wexford (left) and my mam, Joan O'Neill, from Ringlestown, Kilmessan, County Meath (right). Albina and Joan were both working in the Caledonian Hotel. The little girl, Geraldine Ryan, is the daughter of the hotel's proprietor.'
Mary Smyth

1950 'Martha O'Brien (left) with my grandmother, Anastasia O'Toole, enjoying "sixpenny" ice creams on O'Connell Street in 1950. They grew up next door to one another in Hollyfort, County Wexford, and remained friends when they both moved to Dublin separately in the 1940s. Anastasia was 27 years old when this photo was taken, was married with two children and living in Rathmines.' *Síle Coleman*

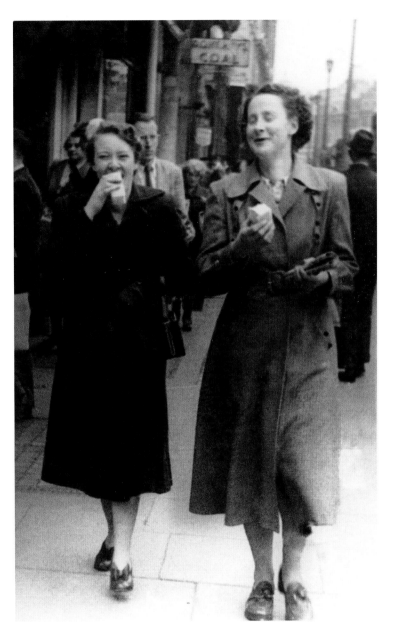

1950 'Jack Flynn (left) and Joe Murray were members of the defence forces. Joe was a Meath man from Ratoath, born in 1916, and Jack was from County Tipperary. They had taken the bus from the Curragh Camp and were walking to the O'Connell Hall in Upper O'Connell Street to visit a "caged birds" show. These army buddies had a keen interest in breeding and rearing canaries. They were neighbours back in County Kildare, and both were married. At this time Joe had three daughters and his family would later grow to seven children. Jack never had any family, so he and his wife, Veenie, became a second set of parents to us Murray kids.' *Joe Murray*

1950 'This photo is of my father Stanley Jerrard-Dunne, recently immigrated from London. He was orphaned during the Second World War – his parents were killed during the Blitz. He was subsequently adopted and in his twenties he moved to Ireland with his adopted family. He was a bookbinder and lived in Dublin for the rest of his life. He and his wife, Pauline, had eleven children.' *Paula Kennedy*

1950 'The man on the right is my uncle Paul McKnight, aged 20, with an unknown friend. He was the sixth child of ten, born to Joseph McKnight and Ann Redmond in Templeogue in 1927. In the late 1940s, he was a steward on the liners from Southampton to Australia and back. He often missed the sailing and had to stay, illegally, in Australia until he could rejoin the liner when it next docked. He ultimately emigrated to Australia and I didn't meet him until he returned to Ireland in 1979.'
Gerry McKnight

1950 'This is my uncle Jim Coughlan. He worked in the Corinthian Cinema in the late 1940s and early 1950s. One of his jobs was to bring cash from the Corinthian over to the Royal Theatre, hence the leather bag.' *Patrick Coughlan*

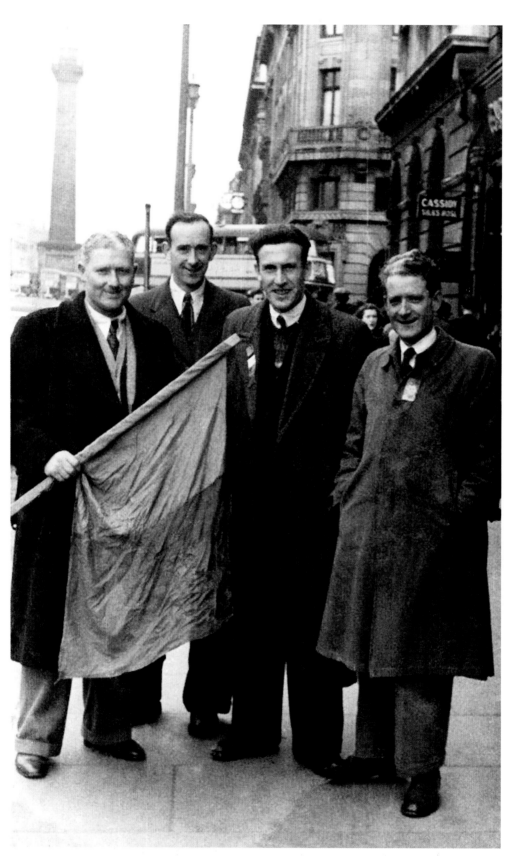

1951 'Left to right: Martin McGreal, Joe Kenny, Harry Kenny and my dad, Frank Kenny. They were all from Westport and they were up in Dublin for the Mayo vs Kerry replay. Mayo won that day. They were all lifelong GAA men and would go to any game Mayo were playing in.' *Tom Kenny*

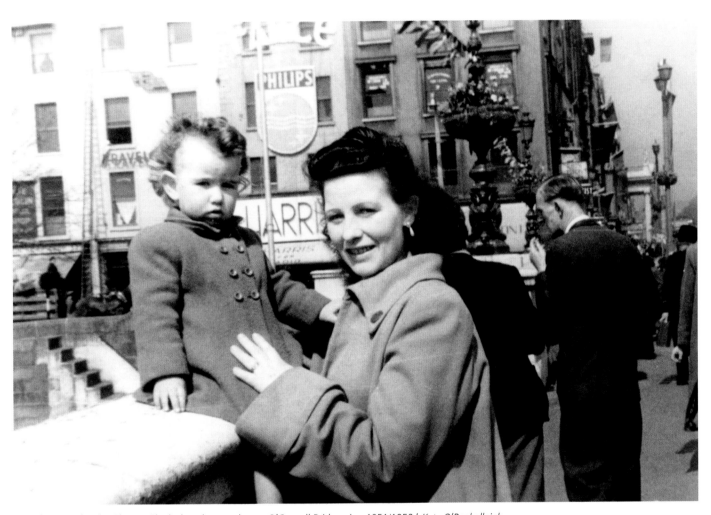

1951 'My grandmother Theresa Sherlock and my mother on O'Connell Bridge *circa* 1951/1952.' *Kate O'Raghallaigh*

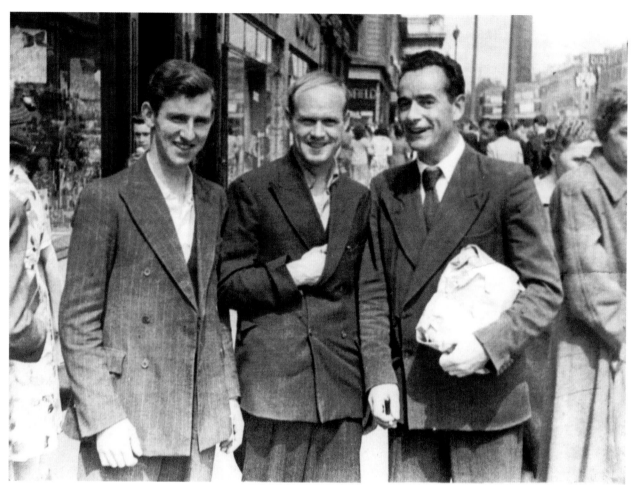

1951 'Left to right: Micheál Hussey, Christy McHugh and my dad, PJ Ryan. A chance meeting of three colleagues from the Irish Sugar Company in Tuam while on a trip to the capital.' *Peter Ryan*

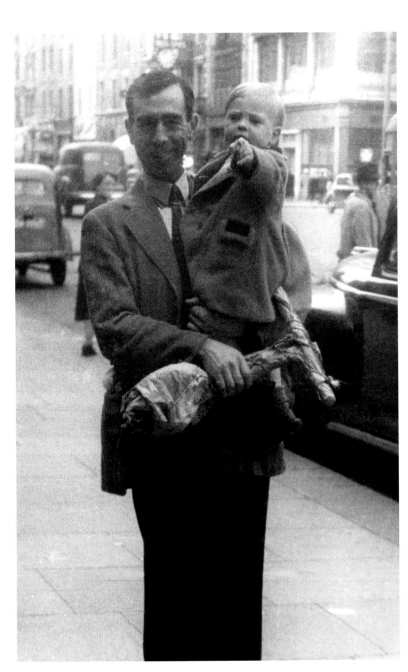

1951 'My father, James Goggins, and me, John Goggins.

'I don't remember the day he carried me across O'Connell Bridge
The carefully wrapped tricycle in one hand and me in the other;
I don't remember the snug little brown coat with the velvet collar
Protecting me from the cold winter of Dublin.
I don't remember who took the snap as I pointed a small finger –
A street photographer, my mother, my aunt?

'I don't remember if I was just showing him the sights
Or marvelling at this new world I had been ushered into;
I don't remember if I had just seen Santa Claus
Or if a large green bus had attracted my attention
I don't remember anything about that unique day
Except that it is preserved in a paper memory

'I have the photo to prove it happened –
But I'll swear I never had the bike!' *John Goggins*

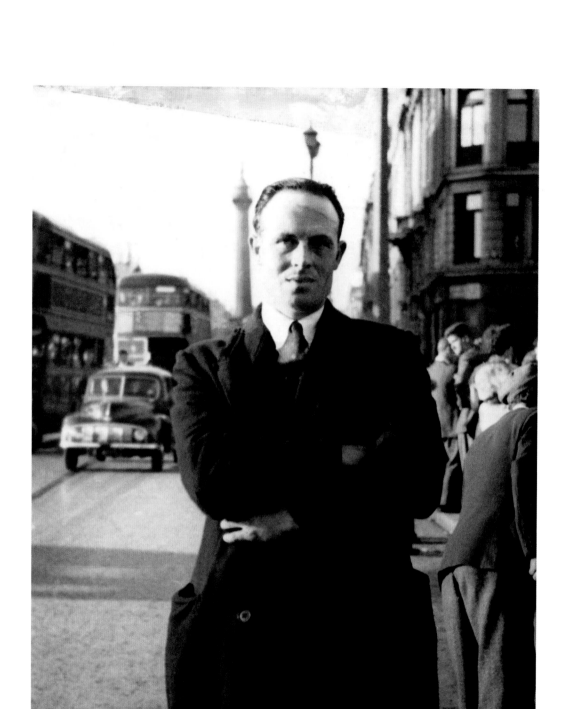

1951 'My dad, Tony (The Blacksmith) Carney from Adrigoole, Knock, County Mayo, visiting Dublin for the All-Ireland football final in September 1951, which Mayo won.' *Patricia Keenan*

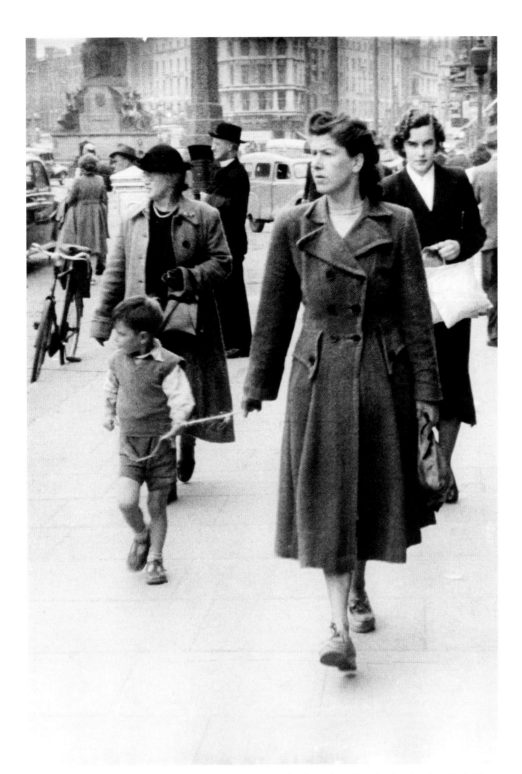

1949 'My mam, Eileen Madden (née Ryan), with my younger brother John tethered to her by a length of old string. It was the summer of 1952 and our family had just moved from Benburb Street to a new parlour house in Crumlin. My mam, like most Dubliners in the 1950s, found it difficult to adjust to her new house in the suburbs. She missed her old friends and family in the city. She continued doing her shopping in town and in this photo she is on her way from Clerys to catch the number 55 bus back to Crumlin.' *Patrick Madden*

1952 'I was a newspaper vendor and the Man on the Bridge took this picture of me aged thirteen. I lived in St Joseph's Mansions, Killarney Street, and I sold newspapers on the trams to Dún Laoghaire/Blackrock and outside Arnotts on Henry Street. The papers included the *Press, Indo, Graphic, Empire News, Chronicle, Sunday Express* and *Dublin Opinion*.' *Joe Phelan*

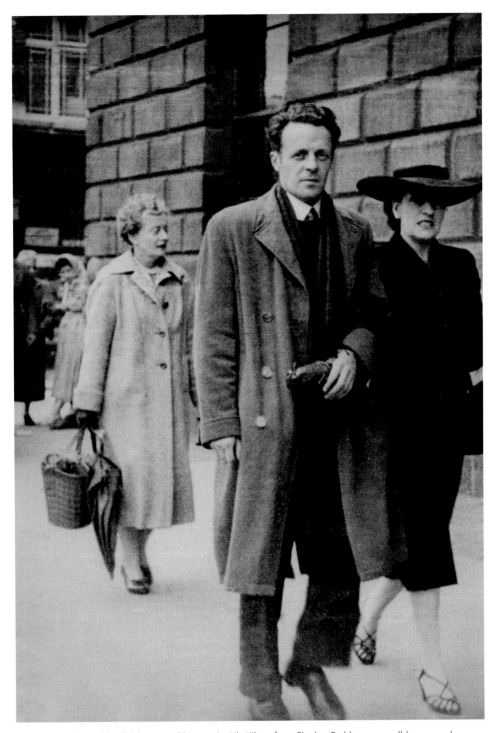

1952 'My uncle, Paddy O'Flaherty, and his cousin, Lily Kileen from Finglas. Paddy was a well-known and engaging ballroom dancer around Dublin from the 1950s to 2000. He won competitions in Mosney and won RTÉ's *Come Dancing*, hosted by Larry Gogan, in the late 1960s. Even in his later years he was a regular on the over-35s and over-50s circuit, travelling regularly to participate in competitions in Blackpool Tower, and will be fondly remembered by the ballroom dancing community. He was a painter decorator by trade and loved nothing more than regaling his customers with behind-the-scenes stories of the glamour beneath the glitter globe. He was a great hit at local weddings – a Rock Hudson-type charmer, always willing to give the glamorous grandmothers a twirl around the floor – and was well known around Cabra, Drumcondra and Phibsboro, where he lived. Lily died in the early 1970s and Paddy himself passed away in 2004. *Ar dheis Dé go raibh a hanam.*'
Gráinne O'Neill

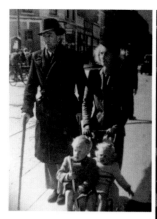
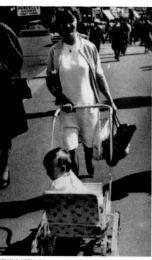
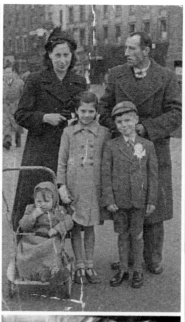

PRAMS

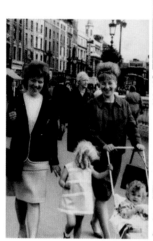
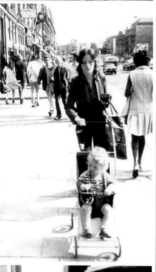
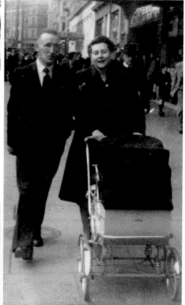
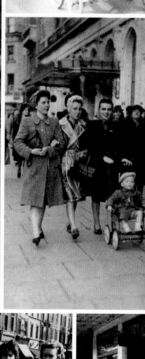

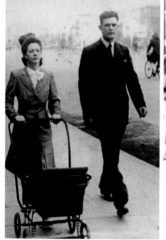
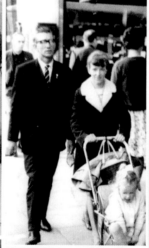
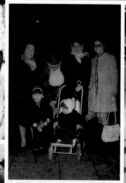

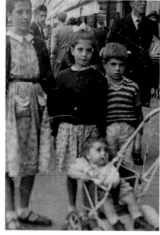
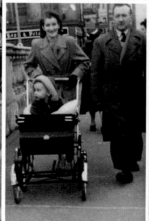
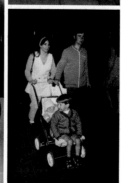
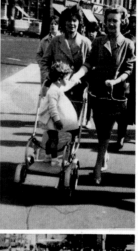

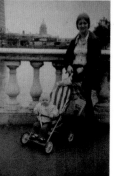

1953 'My sister, Marianne Fitzgerald (née Campion, born 16 September 1947), and myself (born 17 May 1949), in early 1952. We were living then at 32 Parkgate Street, Dublin 8. Note the socks, knitted by our granny, which were – kind of – held up by knicker elastic.'
Michael Campion

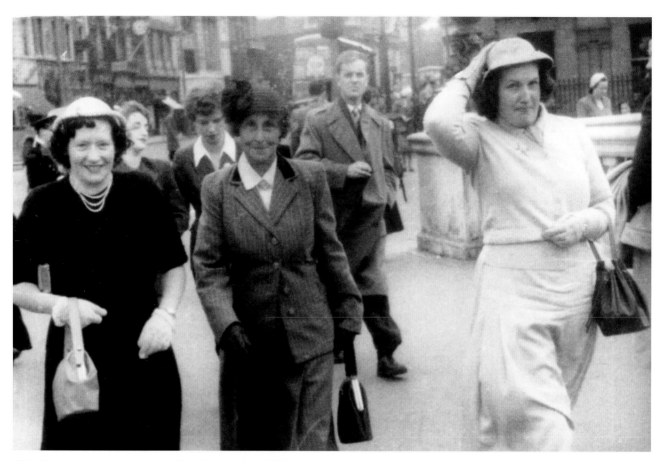

1952 'The day before my parents' wedding. My mum, Rose (Obie) McDermott, my granny, Mary McDermott, and my auntie May McDermott. It was 10 August 1952, and Mammy, her mother and her sister May had just been for afternoon tea in a restaurant. It was quite breezy that day crossing O'Connell Bridge and May, who was to be matron of honour, almost lost her hat!' *Rosemary Connell*

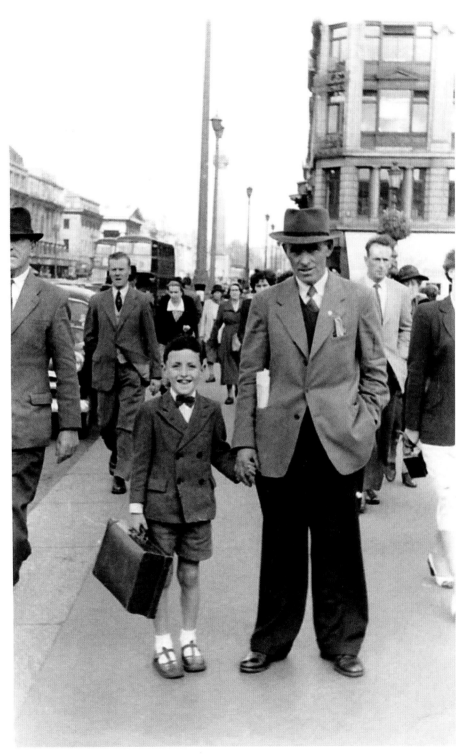

1953 'It was the morning of Monday 7 September 1953 and my dad, Billy Delaney, and I, from Roscrea, County Tipperary, were in Dublin for the Cork–Galway All-Ireland final the previous day. My dad was bringing me on a tour around the city which would include a visit to Woolworths toy store and an ice cream parlour, which is why I look so happy! When I look at this picture it brings back the distinctive smells and sounds of the city at that time, which are so different from today. Every time I walk past this spot it brings back this wonderful memory. On occasion I cross the bridge just to remember.' *Liam Delaney*

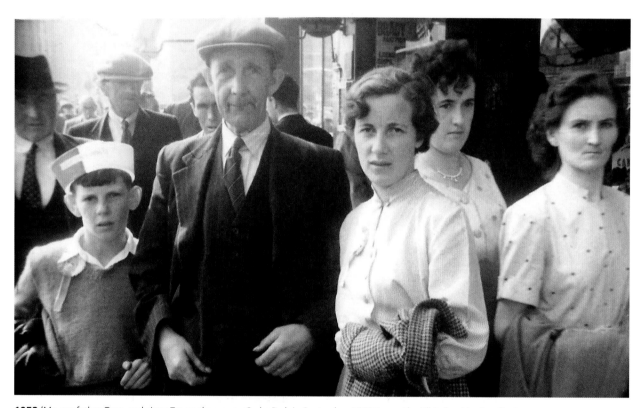

1953 'Me, my father, Tom, and sister Ter on the way to Croke Park in September 1953 to see the All-Ireland hurling final between Cork and Galway. The streets were thronged with the match-day crowd. This was my first All-Ireland and I have fond memories of the day out with my family and seeing my father's native Cork win.' *David Murphy*

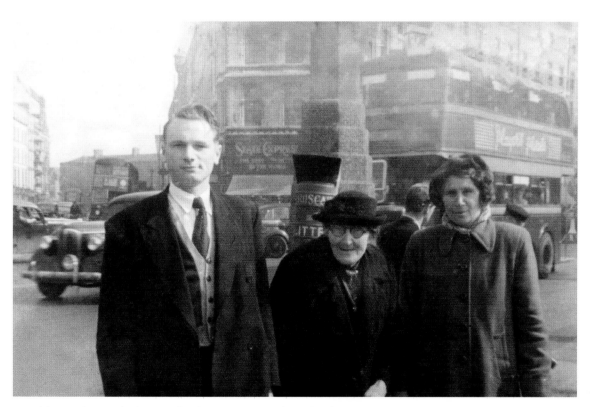

1953 'This is a photograph of my grandmother Maria Corcoran (centre), with my aunt, Katie Jennings, and my cousin, Johnny Jennings. Maria lived in Bellanierin, Castlebar, County Mayo, and her daughter Katie and her family had just moved from Conloon, Castlebar, County Mayo to County Meath. The Irish Land Commission had set up a scheme to relieve congestion in the poorest land of the west of Ireland and the family moved to Mulhussey in County Meath. Maria had paid them a visit a few days before to see the new house and farm, and her grandson took her and his mother to Dublin for a treat. It was on this trip that they met the Man on the Bridge and got their photograph taken.' *Billy Corcoran*

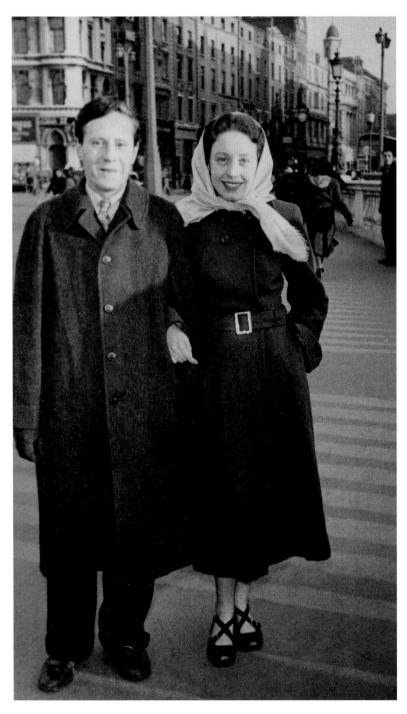

1953 'This photo is of my parents, Christy Moran and Molly Moran (née Roche), possibly the year before I was born, which would make it about 1953. They would have been just nineteen and eighteen that year. They were both Dubliners and worked in the clothing trade all their working lives, which started in Christy's case after leaving school at the age of twelve. Dad was active in the labour movement and at one time became secretary of our local Labour Party branch. Dad and Mam were both into amateur drama, too. Dad played Young Covey in *The Plough and the Stars* at the Arts Theatre in 1956 and they were both in a production of *The Hall of Healing*, also by Sean O'Casey. It was about that time that Brendan Behan was finding his feet as a dramatist, and in fact he came to their wedding reception, which was in 1953, as did one of his brothers, who was reportedly very nice. But Molly described Brendan, who came in later, as "a foul-mouthed young fellow in a coat tied with a string". In his later life Christy was on the committee of Ballymun Men's Centre. Molly became a supervisor and continued to work from home while raising my three sisters and me. Through long years of decline, she never lost that cheerful disposition so evident in this photograph, which Mr Fields rightly centred on her.'
Stephen Moran

1954 'This photo shows my brother Patrick (on the left) and me – "The Twins" – at four years of age, on O' Connell Street. My mother used to dress us both the same until we got a bit older. I don't remember much, but the hats were corduroy.' *John Haran*

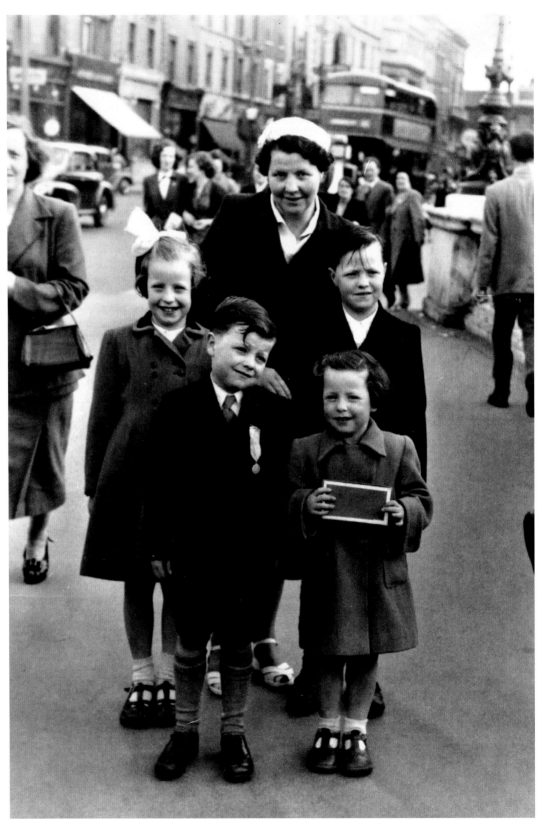

1954 'This photo of the Desmond family of Henrietta Street was taken in 1954. Pictured with their mother, Sheila Desmond, are, at the front, Edward and Pauline Desmond; and behind them Marie and my father, John (who died on 13 January 2013). It was taken on Edward's first communion.' *Karen Desmond*

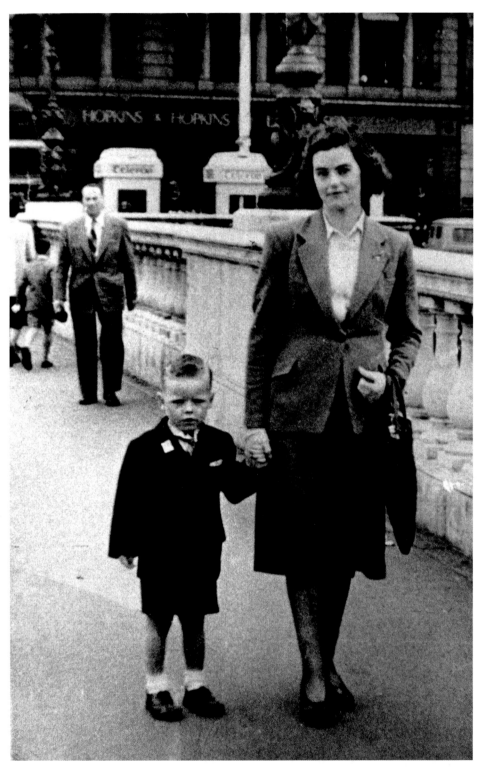

1954 'My mother, Margaret O'Halloran (née Thomas), and myself, aged four, August 1954. When the photo arrived to our home in Swords my mother spent some time explaining to me that the boy in the photo was me. She asked me what I thought of him; to her great hilarity I replied that he was okay but he was wearing my suit. The story has been repeated many times.' *Patrick O'Halloran*

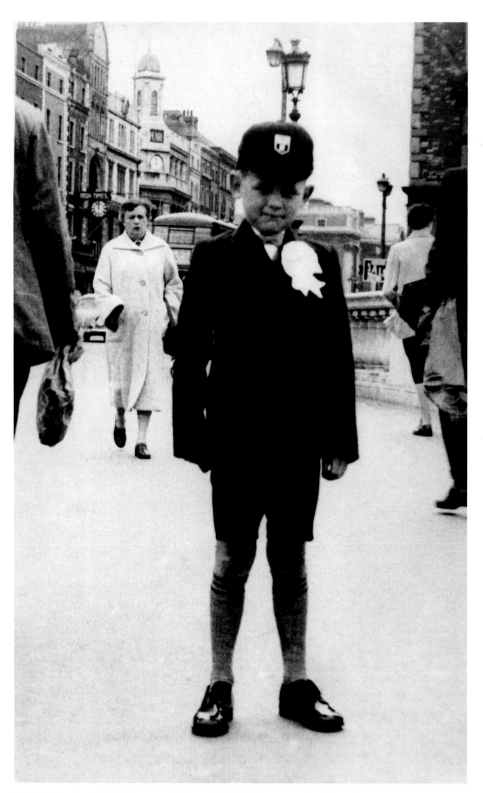

1954 'My husband, Patrick Seery, on the day of his first holy communion. His mother was very proud of him and kept the picture all her life. He was the apple of her eye. We now have it and compare it to our son's first communion photo from 1996. Father and son look strikingly alike except for the background and clothes.' *Síle Seery*

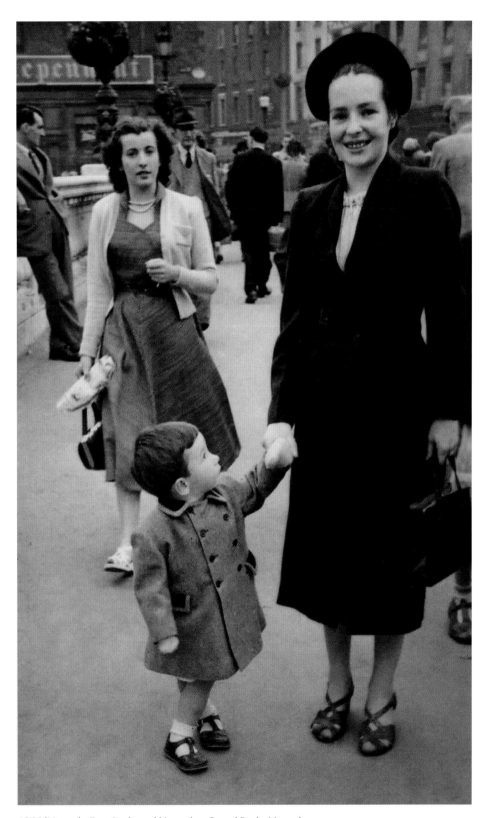

1954 'My uncle, Tony Doyle, and his mother, Carmel Doyle. My uncle affectionately calls the photo "Mum and her Admirer" because he is looking at her with such adoration!' *Louise McCann*

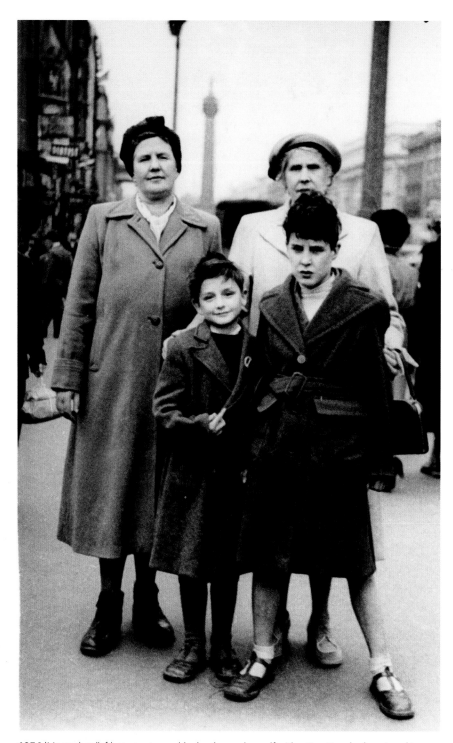

1954 'My mother (left), my aunt, my older brother and myself with a Dan Dare badge pinned to my coat. My aunt would come up from Kilkenny to our home in Crumlin and stay with us for a week or two. During that time she would take us out for ice cream to Cafolla's ice cream parlour on O'Connell Street and of course their ice creams and famous knickbocker glory were always in sundae glasses ... they were the days of old. To get the Dan Dare Badge, I pestered my dear mother to save up enough labels from Horlicks jars to qualify for it. I was a member of the Horlicks Spacemen's Club.' *Eric Gurey*

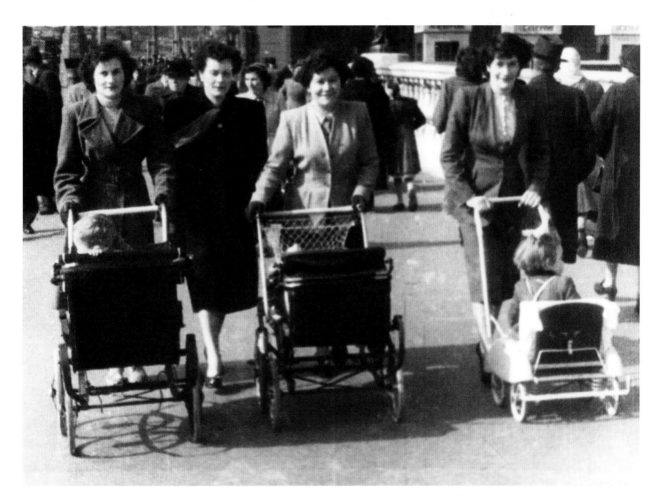

1954 'The Dufficy sisters from Tulsk, County Roscommon. Left to right: Eileen O'Shea, Martha Casserly, May Donaldson and Kathleen Donaldson. I am the toddler in the pushchair, my brother Robert is in the middle pram and in the other pram is my cousin George Casserly, who sadly drowned at the age of two, about ten months after this photo was taken. My mam Kathleen (on the right) passed away at the early age of 38 leaving four young children, and her sister May married my dad and reared myself and my three brothers. The Dufficys were a very close family and even to this day we, as cousins, keep in touch with each other. Eileen and May had a hairdresser's shop in Cabra.' *Amelia Punton*

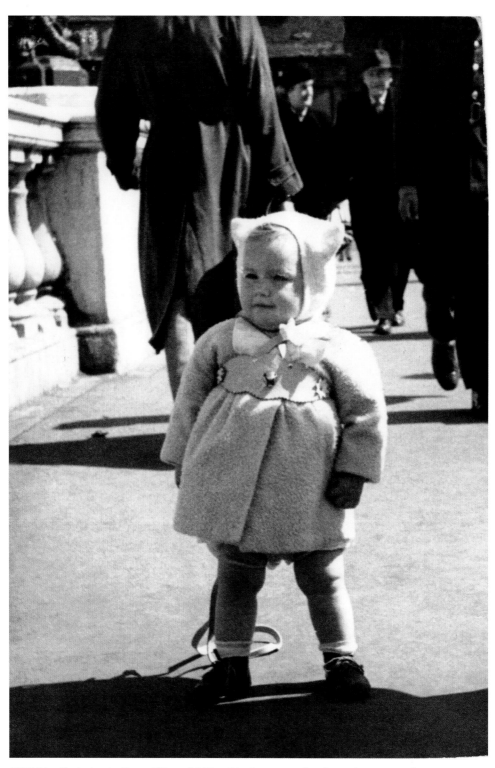

1954 'My wife, Audrey Larkin, on O'Connell Bridge. This picture was taken during the summer of 1954 on a day out in the city with her mom and dad, Patricia and Kevin Larkin. They lived in Cabra at the time. She is now mother to six children and grandmother to four granddaughters. She takes a lot of photos of them.'
Thomas Keenan

1954 'This photo, which was taken in the mid-1950s, shows our mam, Joan Cassidy (née Barrett) on the left, in town with her friend Kathleen O'Sullivan (née Dixon). Kathleen would go on to graduate from Templemore to become one of the first five ban gardaí ever to join the force.' *Alison Cassidy*

1955 'My grandparents Louis and Peggy Moylan outside the Metropole cinema in 1955. Louis was originally from Kildysart in County Clare and Peggy was from Gormanstown in County Meath. They met in Dublin and were married in 1935. They were both keen cinema goers and loved westerns, especially Randolph Scott movies.' *Deirdre Madden*

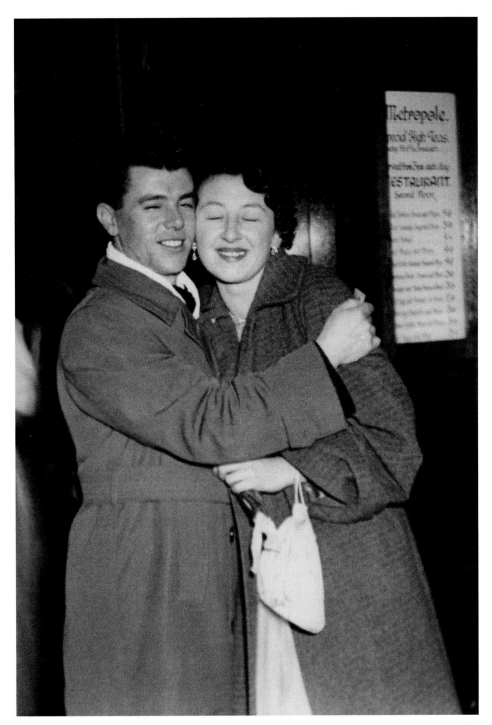

1955 'My parents, Frank Morrin from Kickham Road in Inchicore and Ann D'Art from Bangor Road in Crumlin, at the Metropole on 14 November 1955. They married on 31 March 1959 and went on to have four children. They originally lived with Ann's mother at 107 Bangor Road, Crumlin, later moving to Galway in 1970, where Frank was assistant area rail manager with CIÉ until he retired in 1988.' *Ann Walshe (née Morrin)*

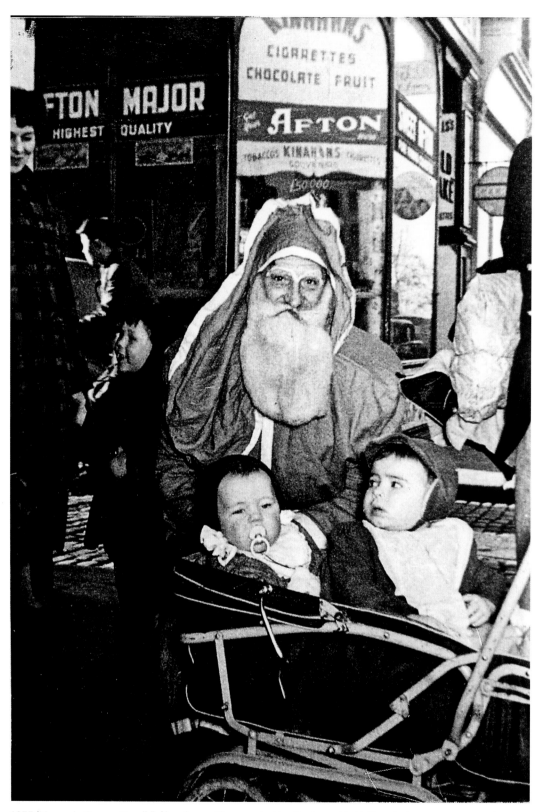

1955 'My cousin Gregory Carroll (left) and me, with a scary-looking Santa outside McBirney's department store on Aston Quay.' *Niall Reddy*

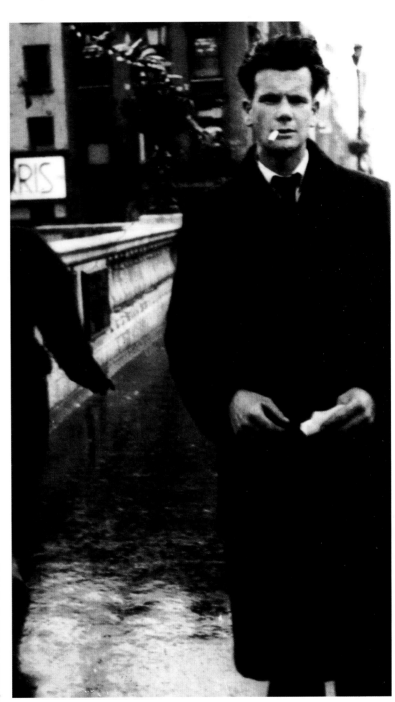

1955 'This is our late father, James (Billy) Cosgrave on O'Connell Bridge long before we were even born. Our late mother, Margaret Cosgrave (née Murphy) reckoned that he was in his early 20s at the time, making this around 1955. It's always been a favourite photo of ours and depicts a different era. It captures him perfectly yet is mysterious as we didn't know him then. He had long since given up smoking and had also lost that wonderful hair!' *Mairéad, Caitríona, Séamus and Michael Cosgrave*

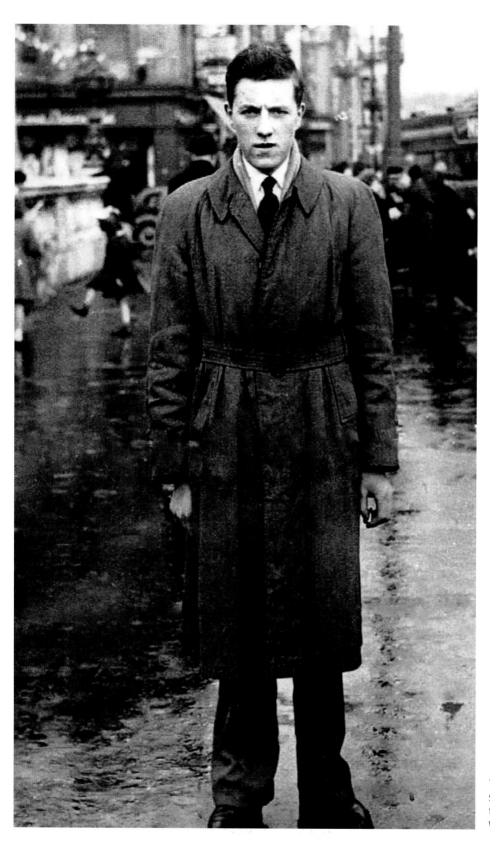

1955 'My uncle Jimmy Concannon, aged seventeen, after he came from Galway to work for my father in our bakery in Winetavern Street.' *Seamus Concannon*

1955 'My aunt, Kathleen Boylan, and Hashim Shehab were dating when this photo was taken in August 1955. They were attending the wedding of Kathleen's brother Jack to Pat Kavanagh, and it was Hashim's first trip to Ireland to meet the family. Kathleen, originally from Spa Street, Portarlington, County Laois, met Hashim, from Mosul in Iraq, in London at a dance hosted by Prince Philip. Hashim was studying at Leavensworth and Kathleen was studying nursing at Hammersmith. They married and went to live in Baghdad for fifteen years, eventually returning to live in Ireland with their two children, Zaid and Jenan. Their marriage survived eight years of separation during the Iran–Iraq war. When Hashim returned in 1986, they settled in Sandycove. Their love endured family, culture, travel, war and time.' *Kay Murphy*

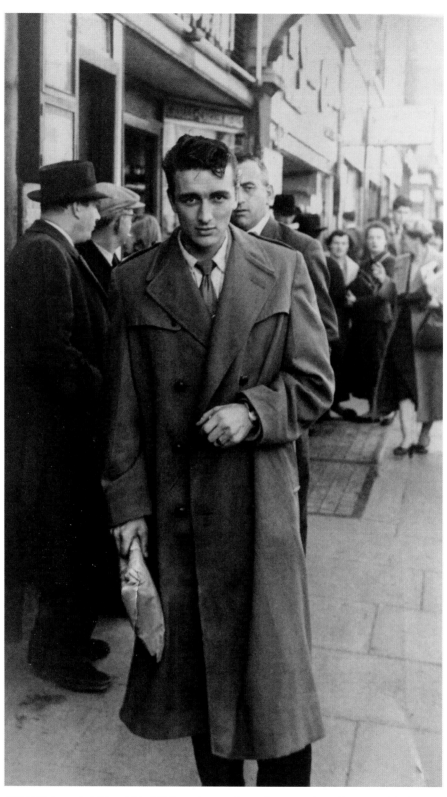

1955 'This is my dad, Edward (Ned) Walker, taken on O'Connell Street in the mid 1950s. Dublin born and bred, and proud of it, he was very style-conscious and always well-groomed. Back then, he was a gunsmith, a carpenter and a cabinet maker. He'd turn his hand to anything.' *Louise Maguire*

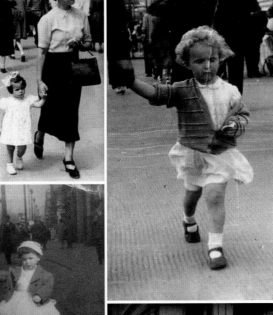
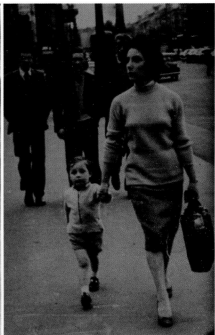
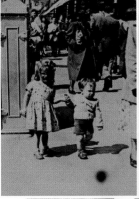
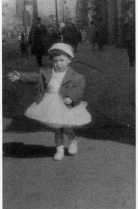
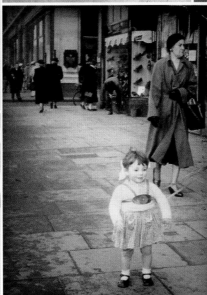
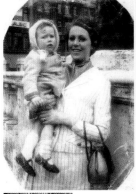
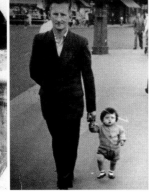
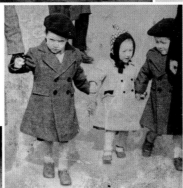
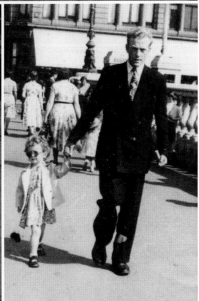

TODDLERS

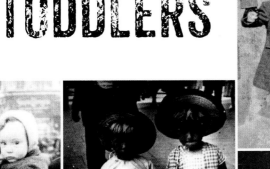
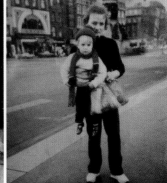
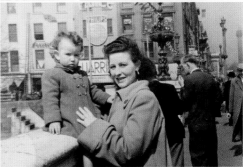
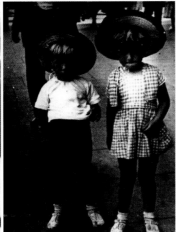
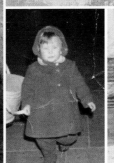

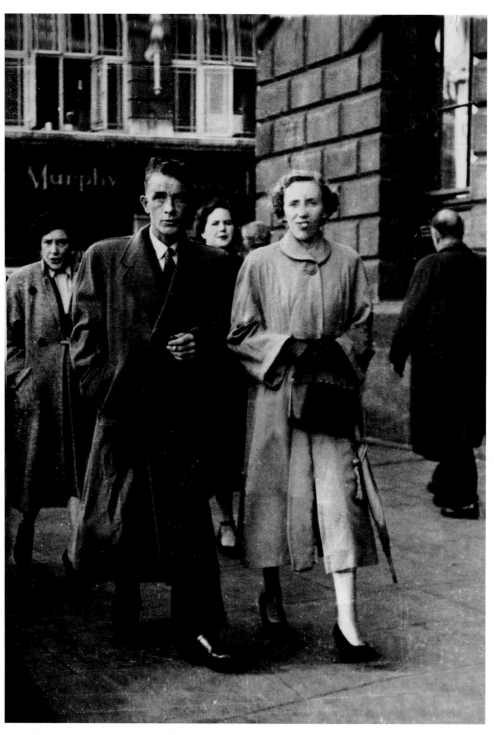

1955 'My parents, Anne and Joe Callaghan from Leitrim, who were married on 3 October 1955. They were childhood sweethearts and Mum was 26 when they married. This photo was taken on their honeymoon in Dublin.' *Mary Quinn*

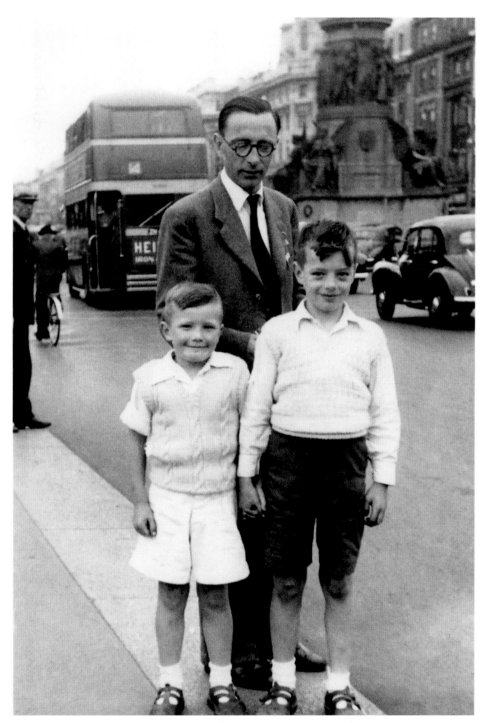

1955 'The father in this photo is Liam Woods; he lived in Blackrock and later moved to Deansgrange. The elder boy is Francis Woods, who lives in the family home in Deansgrange; the younger boy is my father, Felim Woods. Felim qualified as a vet from UCD and made the rather unfashionable move to Northern Ireland in the late 1970s. He still lives in Fermanagh. I love this photo because Dad looks so like my son now. My father loves this photo as there are so many images of old Dublin in the background – the column, the bus, etc.'
Lorna O'Neill

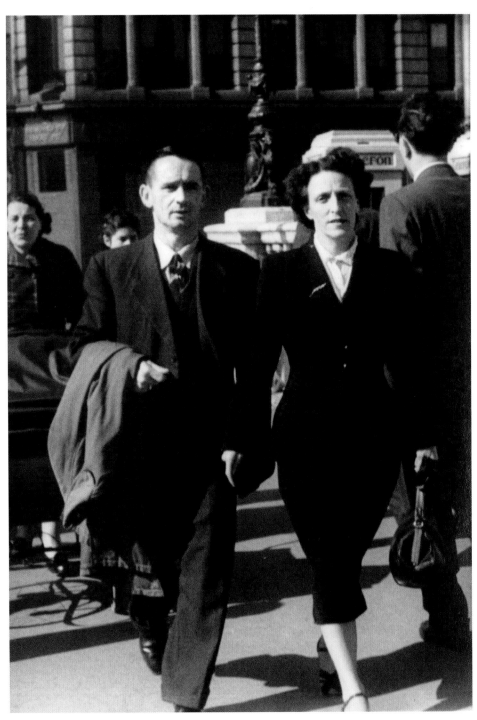

1955 'My grandparents John (Jack) and Rose Devlin (née Moran), around 1955. They had known each other since childhood, when they were both very active in Brookville Lawn Tennis and Hockey Club, near Artane. Jack worked with his father, John Devlin, who had been the official farrier to the Lord Lieutenant of Ireland and later went on to run his own garage – Annesley Garage in Annesley Place (previously Aberdeen Terrace), North Strand, Dublin 3. Jack later worked for the *Irish Independent* as a driver until his retirement in the early 1980s. Rose's father, Charles Moran, had his own shoe shop off O'Connell Street and Rose, along with some of her siblings, continued in the shoe business. She went on to work in Saxones shoe shop on O'Connell Street. Jack and Rose married in 1955 and lived in North Strand and, later, in Artane.' *Aisling Devlin*

1955 'My parents, the writer Frank O'Connor (Michael O'Donovan) and his wife, Harriet. My mother wrote on the back of the photo that it was taken in 1955, and it was her first trip to Ireland. My father was from Cork, she was from Maryland, and they met when he taught at Harvard. They were married in 1953, lived in England for a few years and eventually settled in Ireland. Supportive of his work, she was a sounding board, his first reader. Sometimes he would use stories she told him of her life in Maryland, transposing them to Irish society.'
Hallie O'Donovan

1955 'Our dad, Séamus O'Maonaigh of Ballybough/Harold's Cross, and three sons (left to right), Cartha, Conleth and Ciaran, on O'Connell Bridge in maybe autumn 1955 or early spring 1956. Cartha and I are wearing blazers with our initials embroidered by our mam (Síle). Long before the term "new man" was coined, Dad was always happy and proud to wheel the pram or take the kiddies (eventually seven) out and about.' *Ciaran O'Maonaigh*

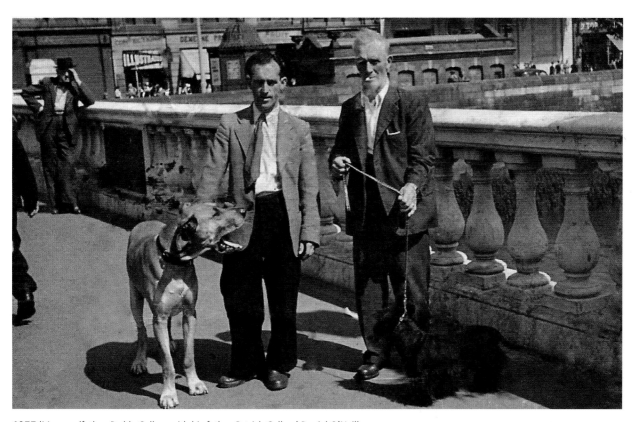

1955 'My grandfather, Paddy Cullen, with his father, Patrick Cullen.' Daniel O'Neill

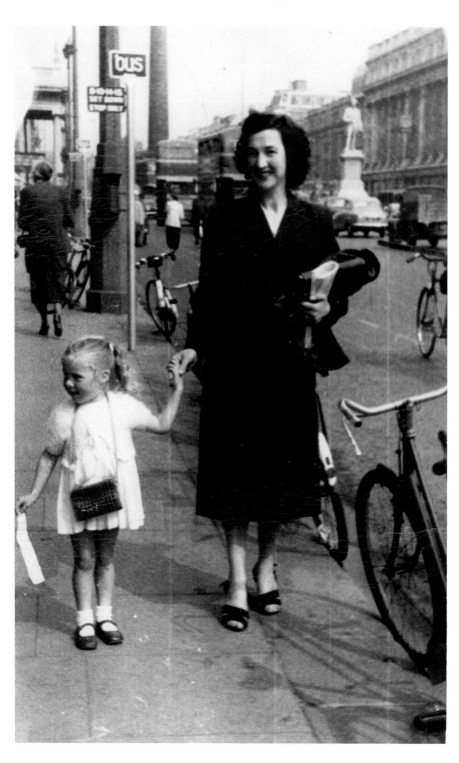

1956 'My mother, Nan Whelan (née Smith), and myself. My mother had lived on Jones's Road and was very at home in Dublin city centre. After moving to Mount Merrion when she married my father, Jimmy Whelan, she took every opportunity to come into "Town". Every Friday she would travel to Moore Street to do her weekly shopping, and then get a lift home with my father when he finished work as a draftsman in the ESB in Fitzwilliam Street. I loved to accompany her into town as she knew all the shortcuts and was friendly with the staff in some of the shops, such as Kelly's fish shop in Moore Street, where we would often stay chatting for ages. Now I enjoy living in Maynooth, but like my mother I still love to come into Dublin for an essential breath of the atmosphere. In the picture you can see Nelson's Pillar, the GPO, Clerys and a bus stop with Irish script. I am holding a bus ticket – at that time children loved to get a long bus ticket from the bus conductor; when he came to the end of a roll there would always be a child waiting to get the long blank end of the ticket.' *Regina Whelan Richardson*

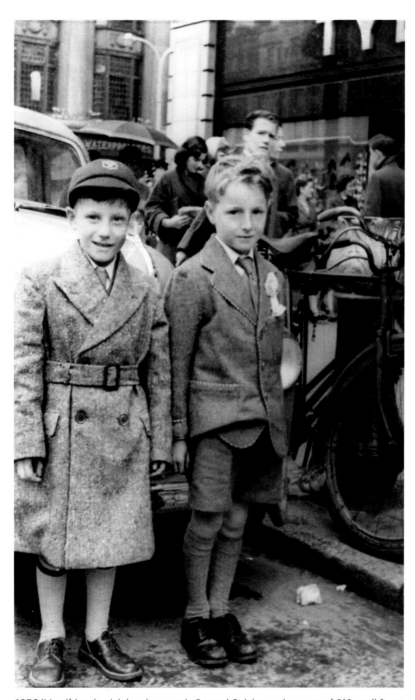

1956 'Myself (on the right) and my cousin Bernard Quigley on the corner of O'Connell Street and Abbey Street in 1956. A photograph is a nanosecond in time, never to be repeated, no matter how often you take the same shot. The reason we were in the city centre was to spend some of our holy communion money in Clerys department store, now sadly gone.'
Tom Howard

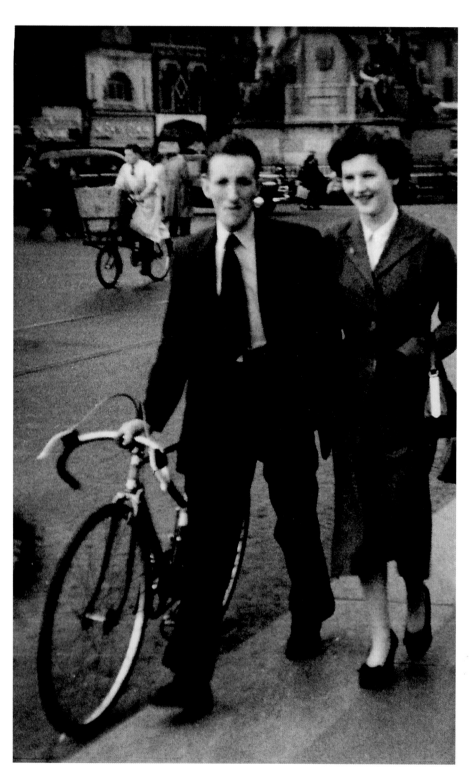

1956 'My parents, Bob Keogh and Mary Cahill, before they married in 1958. Dad worked in Lee Brothers Tailoring in Abbey Street, beside the then offices of Independent Newspapers. He had a half day on Saturdays and he met Mam after work and had the photo taken then. He had his bike because he cycled into work every day from Terenure. They were members of the Orwell Wheelers cycle club and that's where they met. Of course, he gave her a crossbar lift home to Donnybrook later that night!' *Judy Maguire*

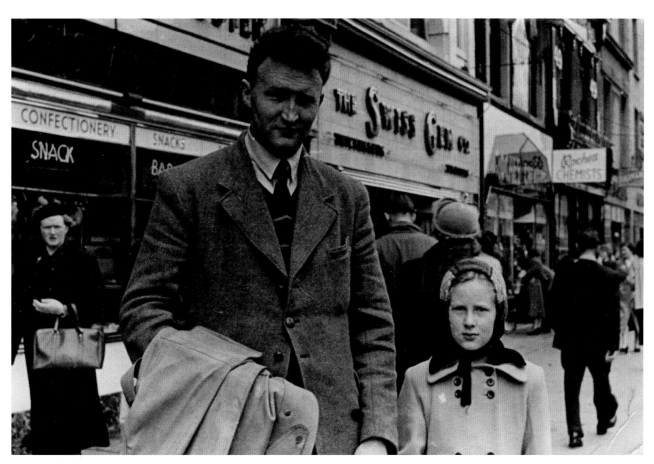

1956 'My dad and I in O'Connell Street in 1953. My dad, Solomon Egan, was originally from County Kerry. He came up to Dublin, settled here and married my mam. I was nine years old when the photo was taken. My dad often took me with him to town.' *Margaret Bollard*

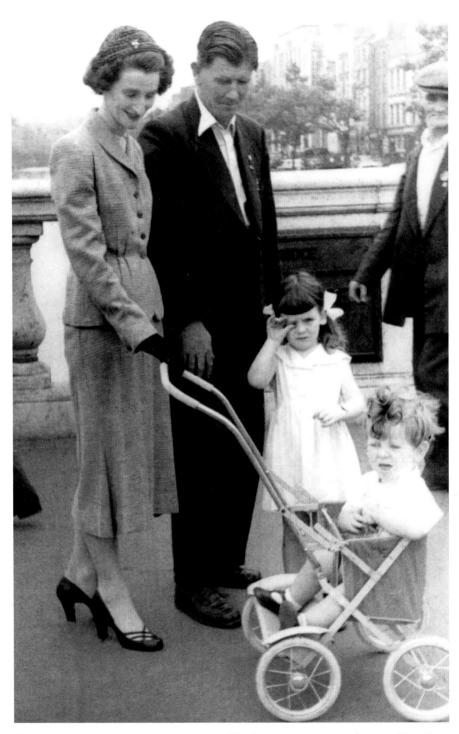

1956 'My parents, Jimmy and Marie Murphy (née O'Hara), my sister Margaret and me on O'Connell Bridge. I remember the buggy, or go-kart, as we used to call it in those days.' *Colm Murphy*

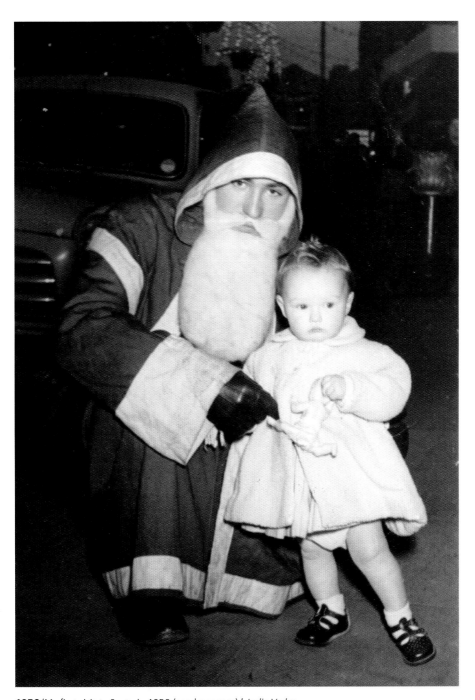

1956 'My first visit to Santa in 1956 (aged one year).' *Lydia Varley*

1956 'George Anthony Rickard (1930–2009) of Howth, County Dublin, who was home on leave in 1956 from the US Army. At the time he was stationed at Flak-Kaserne, Ludwigsburg, and likely a part of the 4th Transportation Battalion. The picture was unsolicited, but it is a cherished family photo, and the only picture of my father in his full US Army uniform. My father served in the US Army from May 1955 to May 1957. *Seán T. Rickard*

1957 'At the back are my mother, Jane Condron, her sister, Elizabeth Malone, and my sister Ethne Condron. In front are my sister Patsy, me, and my father, Andy Condron. I think I'm looking up at my father with an expression of admiration. He was a very fit guy, an ex-boxer; he was good at everything, an all-round athlete. We were on our way to our relations in Pearse Street and Cabra. I think people were fitter then because we walked everywhere. Fantastic memories, thanks to Athur Fields.' *Christy Condron*

1957 'Carol O'Hara, my sister, originally from Donnycarney, now living in Rhode Island, USA. She is on her way back from the hospital after having her arm put in plaster. I think my mum is holding the lead. My sister is now all grown-up but sometimes I think she should still be on the lead! She's an amazing sister.'
Sandra O'Hara

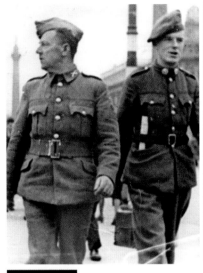

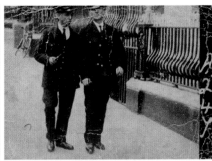
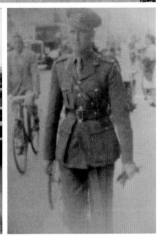

UNIFORMS

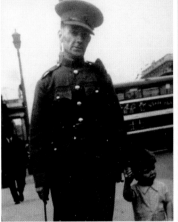

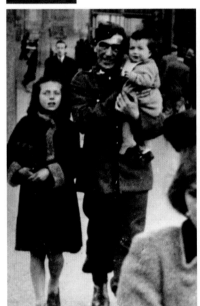

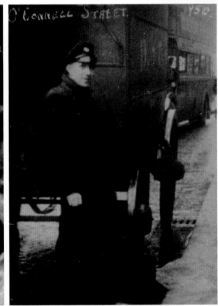

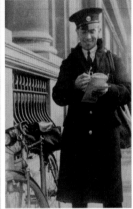

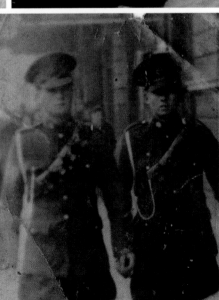

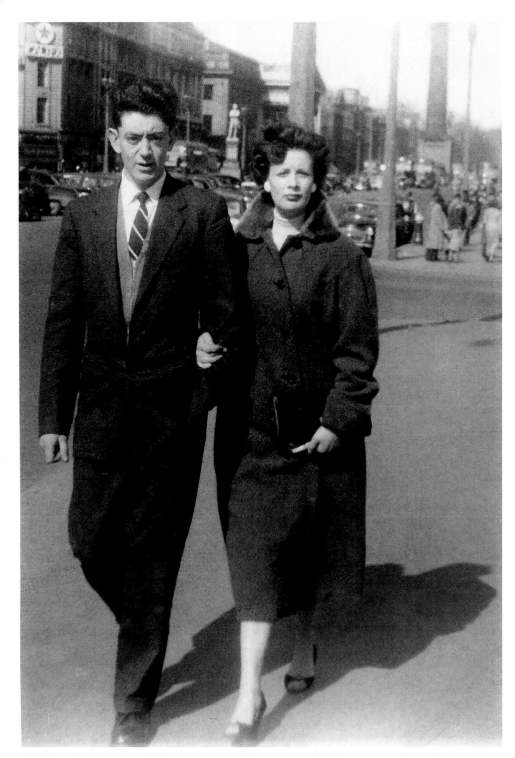

1958 'Betty Swords and myself. We were married the following year, 1959. We were probably heading to the Royal Theatre, where there was a stage show, the Royalettes, and you'd see a movie there as well. I knew that Betty was the woman for me; I was in love with her. More than likely she got a birdie on the cheek at the cinema in the midst of all the smoke. We had five children and eleven grandchildren. Still happily married and still giving her the odd birdie on the cheek.' *Paddy O'Donoghue*

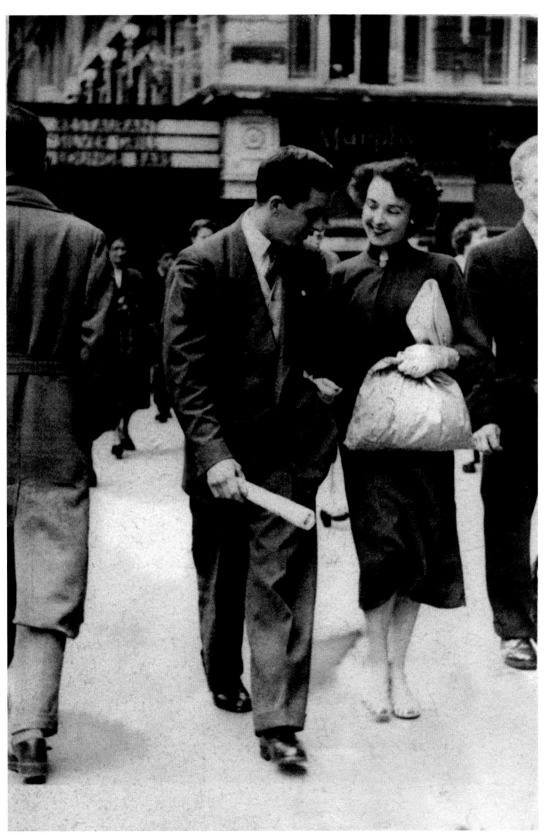

1958 'This is a treasured photo of my parents, Michael (Bernard) Corrigan and Mary (Marie) Mullally, when they were courting. My mother said it always annoyed her that he turned up for their date with a newspaper.' *Declan Corrigan*

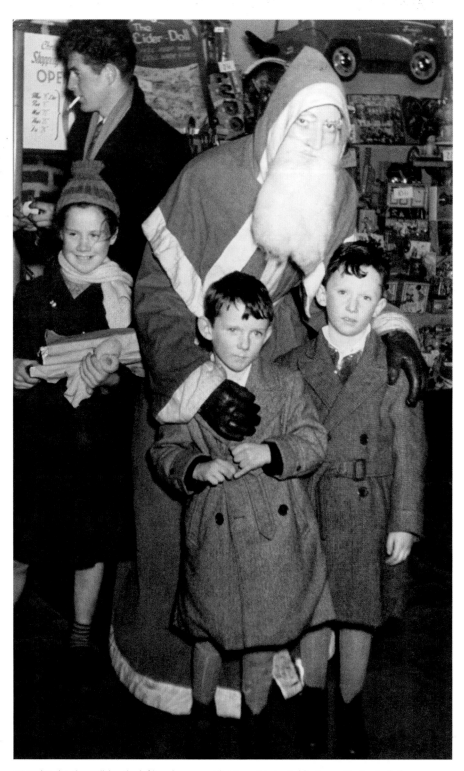

1958 'My brother Bill (on the left) and me on a Christmas trip to Dublin to see Santa. Back then, and I'm sure to a lesser extent even now, it was customary for people from the country to come to Dublin for a Christmas trip. We travelled from Kilkenny with our mam and dad on that particular day to see the Christmas lights and visit Santa. The one abiding memory I have is of having a meal at the Paradiso restaurant in either Westmoreland or D'Olier Street. It was the first time I encountered chicken Maryland.' *John Bergin*

1960 'This is my brother David Griffin with our maternal grandmother, Brigid Wade. He was her first grandchild and they had a very close bond. Having married at 35, quite late for her time, she nevertheless produced five children. When this photo was taken she was the widow of a former Guinness worker, and living in Stoneybatter. Originally from a farming background in County Carlow, she always dressed quite plainly, in sharp contrast to her four very stylish city daughters.' *Linda Griffin*

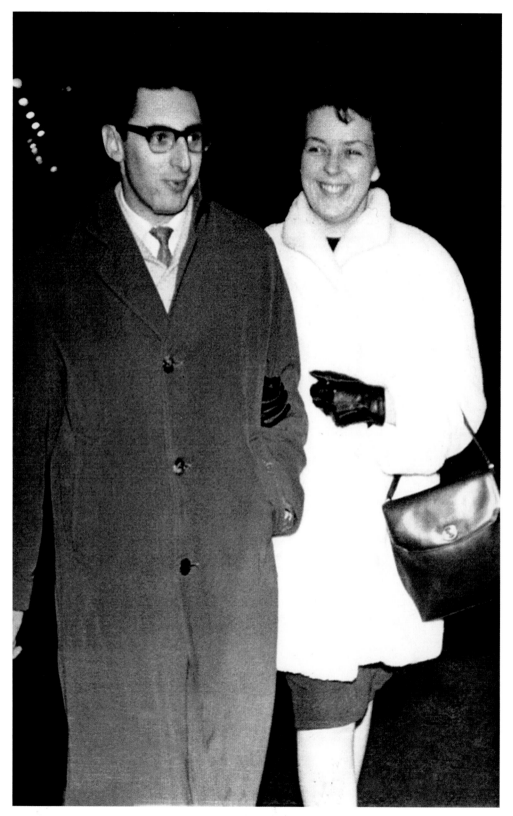

1960 'My parents, Ian Henry and his "mott" Noeleen Phillips. Dad was a jazz pianist, composer and arranger, who was a pioneer of jazz in Ireland and a regularly featured artist on the RTÉ programme *For Moderns*, presented by T. P. McKenna. They met when Noeleen, a classical piano student, became interested in jazz (thanks to pirate station Radio Luxembourg) and began to take classes with Ian at his home in Kimmage Road. Ian qualified in medicine at the Royal College of Surgeons in 1964. They were later to become Ian and Noeleen Garber.' *Debora Garber*

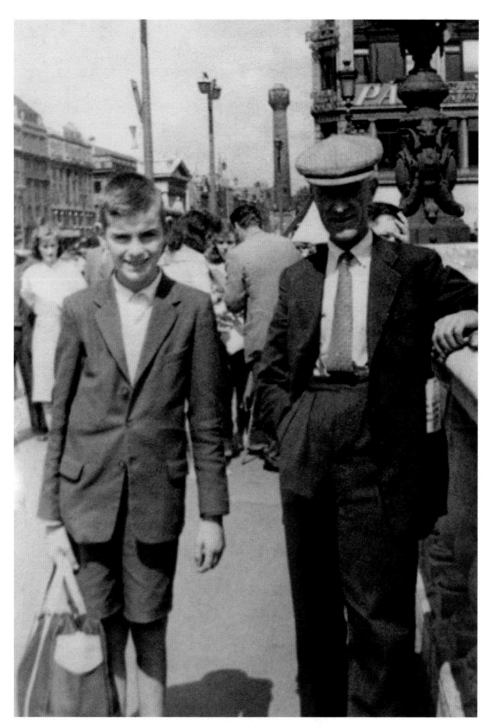

1960 'Myself and my uncle Ned Phelan in the summer of 1960. When my mother got TB in 1947, all eight children were sent to relations. I had just been born and I was sent to my uncle in Newbridge. After six months, my mother was better, but they decided to hold on to me in Newbridge because they were fond of me. My parents would come down from Crumlin to get me and my aunt would say, "Leave him for another while, leave him for another while." They left me for another while and I'm there ever since. I have great memories of growing up in Newbridge and all the mischief I got up to. People still know me as Liam Phelan but I am most certainly Liam O'Keefe.' *Liam O'Keefe*

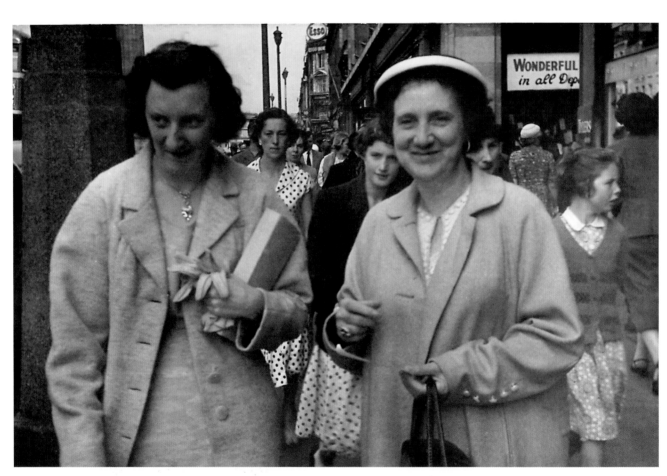

1960 'My aunt Eva Ray, on holidays from Boston, Massachusetts in Inistioge, County Kilkenny, in the early 1960s. She was shopping in Dublin with her friend Mary.' *Bernice Maher*

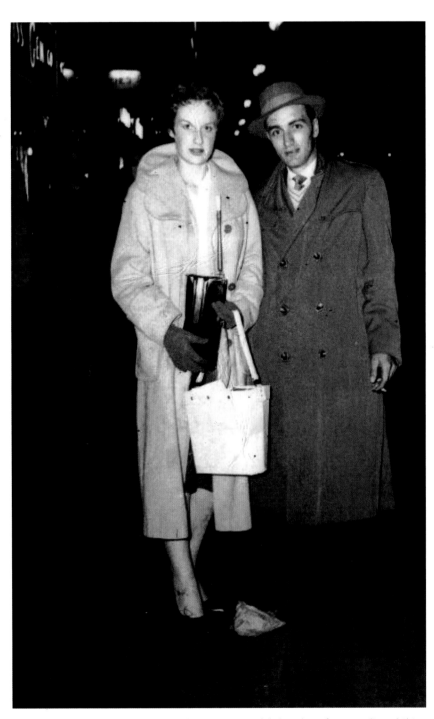

1960 'Edward (Ned) Walker and Elsie Collins, my mam and dad. Ned was from Crumlin and Elsie was from Lucan. This was taken around 1960. I just love this photo; they both look so young and glamorous.' *Louise Maguire*

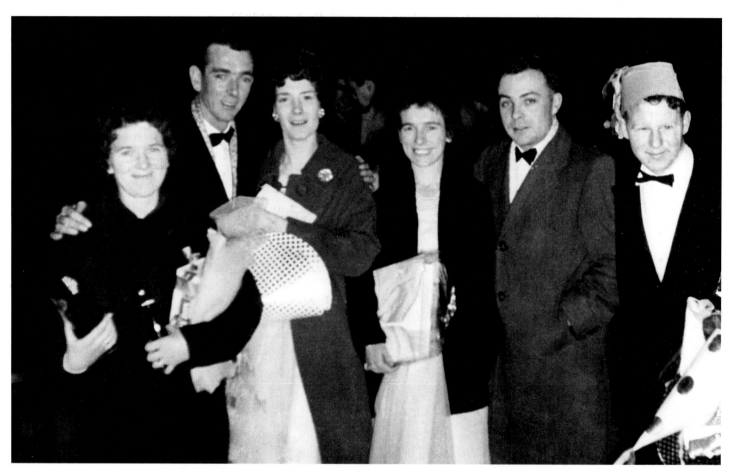

1961 'Left to right: Annie O'Connor (née Doyle), John Doyle, Jane Doyle (née Murphy), Nuala Leech (née Doyle), Colm Leech and Brendan O'Connor. They are all relations, and Nuala and Colm were my parents. They were attending a post office dinner dance in the Metropole around 1961. One of them worked in the post office and they'd go to this dance regularly. I love old photographs of them; they were a very close family and socialised together. Seeing them when they were younger, and the style of their clothes, captures memories of a different time.' *Theresa Lawlor*

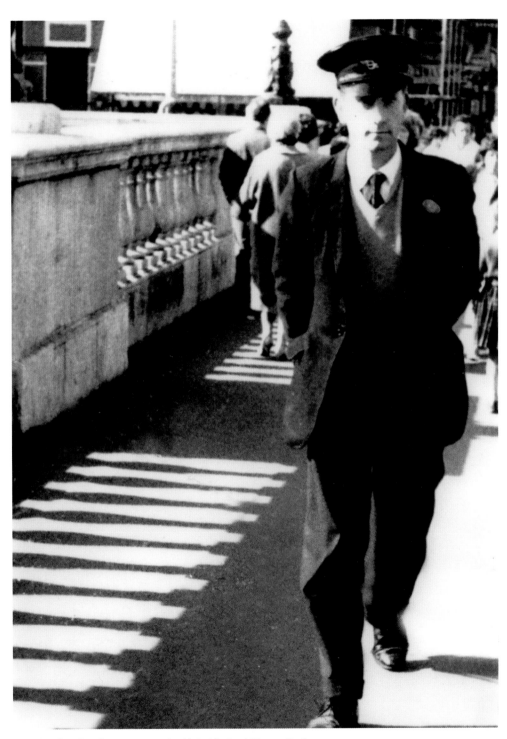

1961 'My first day after starting work with Dublin Bus.' *Vincent Hughes*

1961 'The day I brought my fiancée Patsy Kiernan from Birmingham to meet my parents in County Dublin. A proud moment. She was an Irish dancing teacher and I met her when I was driving a bus in Birmingham. She complained about my driving and I offered to apologise over dinner!' Terry Denneny

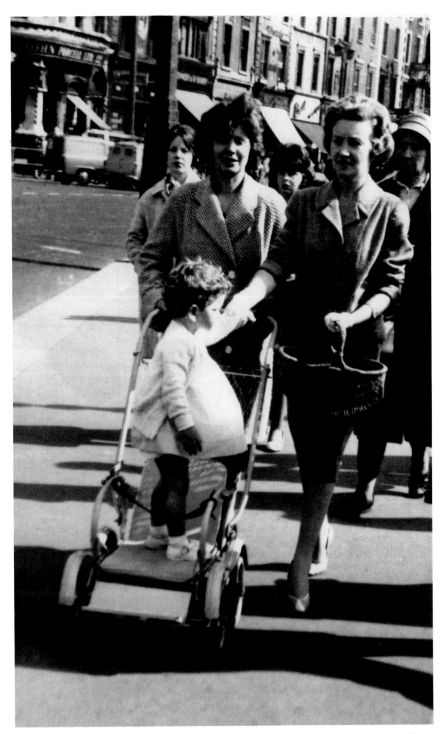

1961 'This photo was taken in the early summer of 1960. It shows my mam, Doris Curran, and her best friend, Mona Dunne, with me standing in the pram. Mona is holding my hand. The photo was taken on O'Connell Street Bridge. My mam and Mona used to go into town every week and Mona always carried that basket, which was the fashion then. In those days they always dressed up to go into town. Mammy had two other children, my brother Liam and sister Ann Marie. Mona was my sister's godmother. We lived in Phibsboro and Mona in Cabra. This photo has pride of place in my living room. Both my mother and Mona are now dead and it is only as I get older that I realise what beautiful-looking women they both were.' *Marguerite Curran*

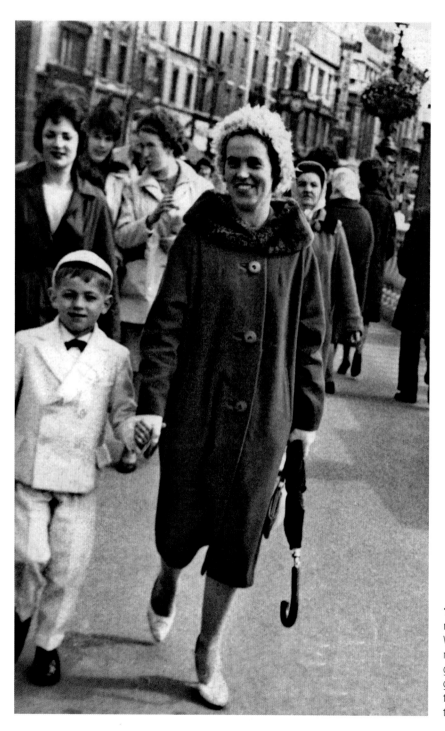

1961 'My mum, Marcella Ingle Kelly, and me, on the day of my first holy communion. We had travelled from Rathfarnham on the number 16 bus and we were heading to my granny's. The white suit was made by my great uncle, Billy Grattan, who was a tailor at the time, and the design was my idea – long trousers.' *Ned Kelly*

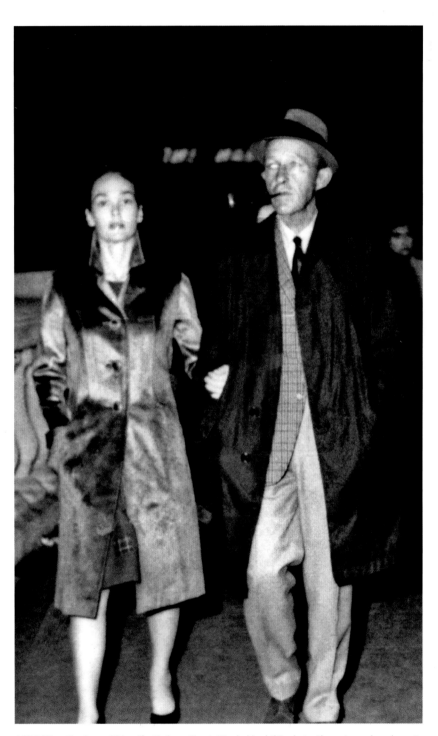

1961 'Bing Crosby and his wife, Kathryn Grant. My dad had this photo; I'm not sure how he got it, but he loved the movies, dressing up and dancing!' Ellen Breen

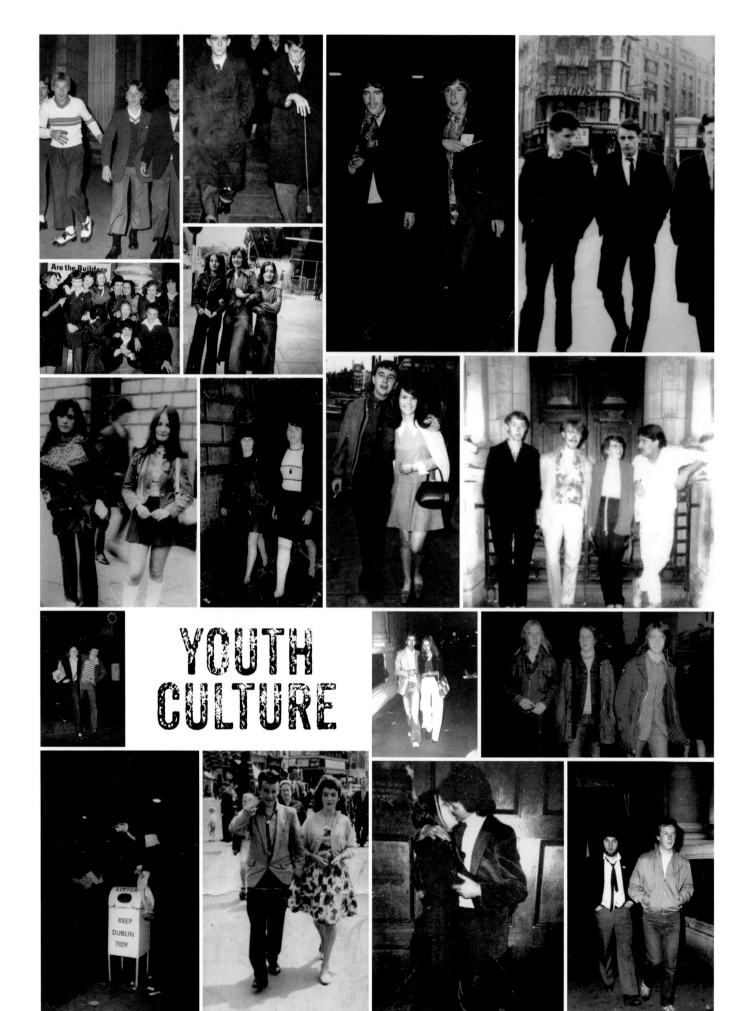

YOUTH CULTURE

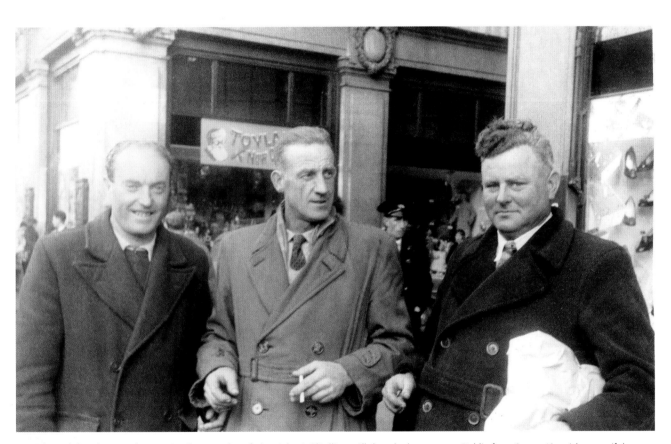

1962 'From left: Johnny Heelan, Denis O'Leary and my father, John J. O'Sullivan. All three had come up to Dublin from County Limerick to see if they could get a patent. Johnny delivered fish locally on a Vespa and had come up with an invention that would heat the handlebars. Unfortunately, he didn't get the patent, but he continued to deliver fish.' *Sean F. O'Sullivan*

1962 'Myself, on the left, with a colleague. We were nursing in Our Lady's Hospice, Harold's Cross, at the time and were out collecting donations for the hospice. We had great fun.' *Breda Feeney*

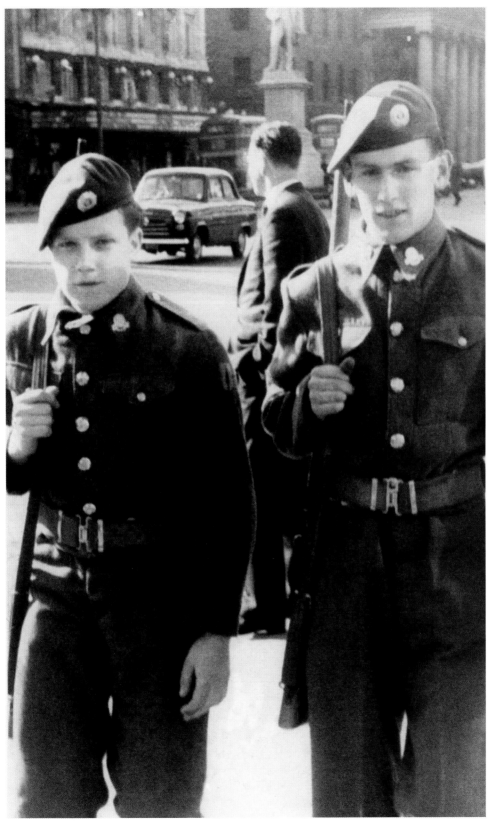

1962 'This photo was taken after the Easter Military Parade in 1962. It shows me, on the left, and Tony Byrne. We were both members of the FCA, B Company, 7th Battalion.' *Tony Connolly*

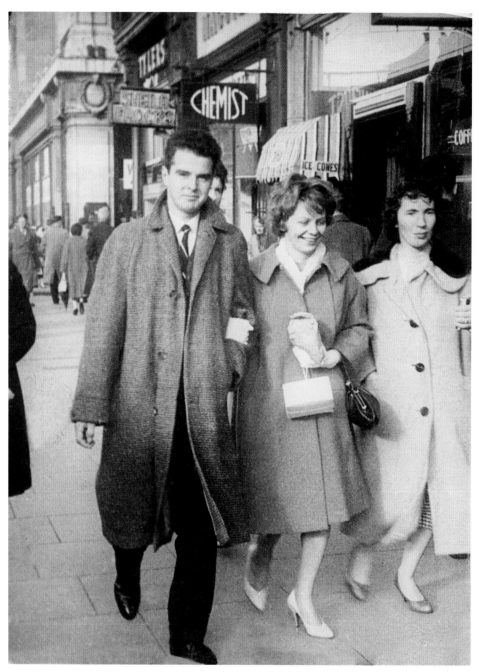

1962 'Rita O'Reilly and me in O'Connell Street in late 1962 (Clerys is in the background). The woman on the right is a complete stranger! Wearing your collar turned up was a fashion statement at the time (probably influenced by Elvis). Rita is carrying a bag of sweets and a cake bought in the Kylemore Bakery in O'Connell Street. We were on our way to visit a friend, Noel Heary, in Blanchardstown Hospital, which was then a TB hospital.' *Patrick Conneely*

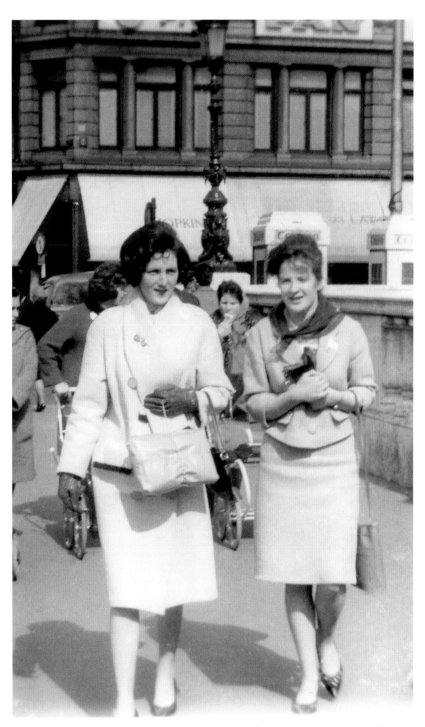

1962 'Myself – Marie Greene (now Marie Quinn), on the left – and Ann Kerr. This was the first time we met up after leaving school in 1961. Ann went to nurse at Portiuncula Hospital and I went to nurse in the Channel Islands. It was my first holiday back in Dublin and I met up with Ann, my old school friend, on her day off work. We had a lovely day in Dublin and were delighted with our photo.' *Marie Quinn*

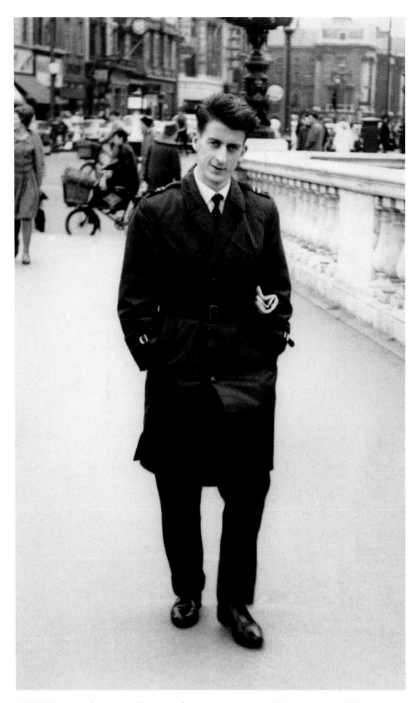

1962 'This is my da, Jimmy O'Reardon, from Donnycarney, Dublin 5, taken in 1962 on O'Connell Bridge by a photographer from Max Studio – not Arthur. He was 21 and had just come from signing his contract to join Irish Shipping (on Aston Quay) when this photo was taken. Soon after, he set sail around the world and in 1964 emigrated to Australia. In 1974 I came along (after my brother). Although my da has been all over the world and has only been back to Dublin once in all that time, he is still fiercely proud to be Irish (and sounds it). More important, he's taught my brother and me to be proud too.' *Siobhan O'Reardon*

1963 'Myself, Sean O'Meara of North Strand, on the left, and Sean Lynch, Ballybough, on the right. At that time, lads would be wearing a shirt and tie, but things were becoming a bit more casual. I'm wearing a sport shirt that I picked up in Elvery's. Sean always dressed formally but expressed himself with his hairstyle.' *Sean O'Meara*

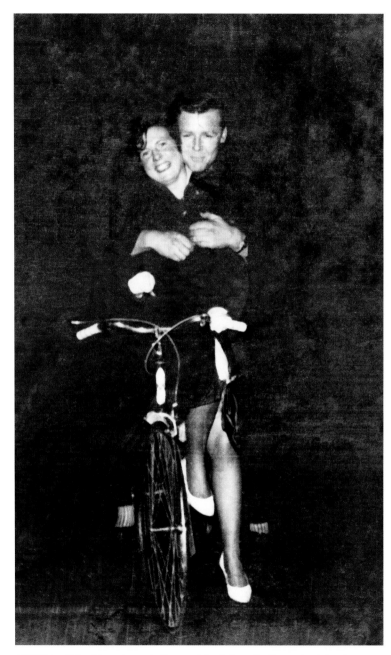

1963 'Myself, Kay Monaghan, née Byrne, originally from Coolbawn, Aughrim, County Wicklow, now of Mullagh, County Cavan; and Dennis Foxe, originally from County Wexford, now of Ashbourne, County Meath. This photo was taken the night of a bus strike in Dublin. Dennis was giving me a crossbar lift on his push bike to the National Ballroom on Parnell Square.' *Kay Monaghan*

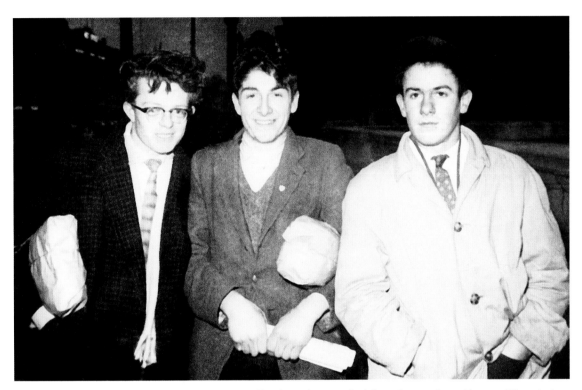

1963 'From left: Thomas Conroy, from County Laois, myself and Patrick Dorney, both from Cloneen, County Tipperary. We worked together in Terenure College when it was a boarding school, serving in the kitchen and waiting on tables. I was only fifteen years old and it was my first time in Dublin. I didn't go to secondary school and I felt the people in the boarding school were privileged. They'd have tennis racquets for the court while we'd be using our hands in the handball alley. When the kids went home for summer, we'd clean up the locker room and find discarded tennis rackets, *Playboy* magazines, fancy jackets and other items of clothing. We'd be delighted. It was an education in itself; it taught me about money, as we'd have to manage our own wages. I got into the CIÉ dining cars on the back of having done that job.' *John Roche*

1963 'My dad, Tommy Nee from Cavan, aged 20. The photo was taken in 1963. That day, he thumbed a lift to Dublin and he dressed well to make sure he'd get a lift quickly. I love how dapper he looks and I love that type of photography – photographs were more casual and unguarded in those days. He was dressed so well; I think people looked after their clothes more back then. He still has those gloves; they were his driving gloves and were probably the first pair of gloves he got when he got his first car, a Mini. He still looks dapper to this day.' *Emma Nee Haslam*

1963 'Myself and my then boyfriend, Michael Kennedy, now my husband of 50 years. He was a bus conductor at the time, then went on to become a bus driver from 1964 to 2005. He drove every route and knew the city extremely well. This photo holds great memories. We were so young and have now been together for so many years that it has become a timestamp of the beginning of our relationship.' *Nuala Kennedy*

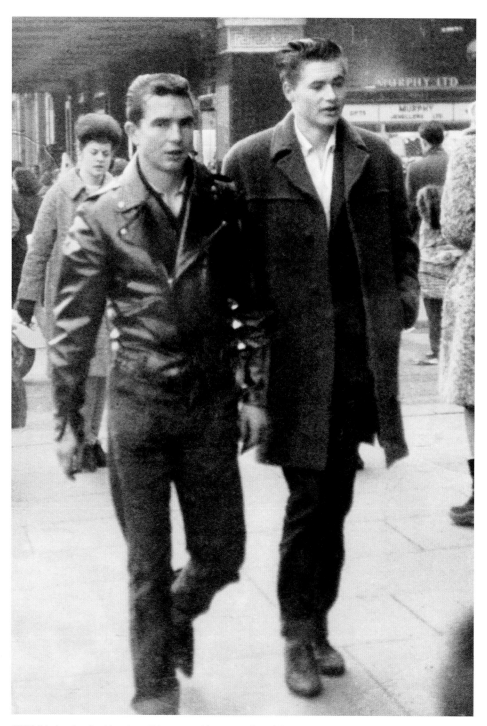

1963 'My brother David and me. We were Teddy Boys and we felt very cool. My brother is wearing a biker jacket that he borrowed from me. I'm wearing what at the time was a very fashionable three-quarter-length coat. Before then, coats used to always hang down to below your knee. At the time, rock and roll music was coming on to the scene.' *Patrick English*

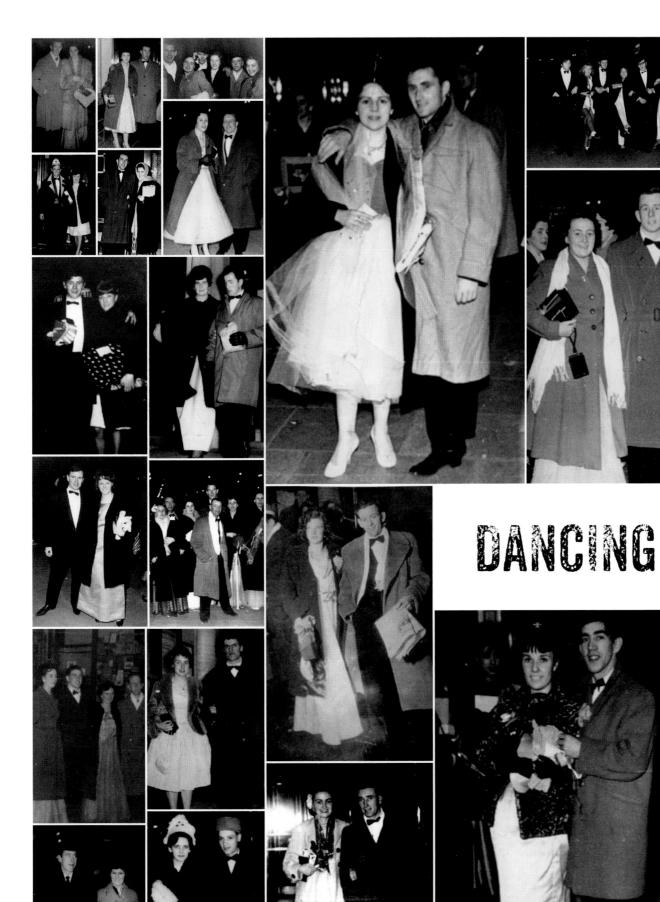

DANCING

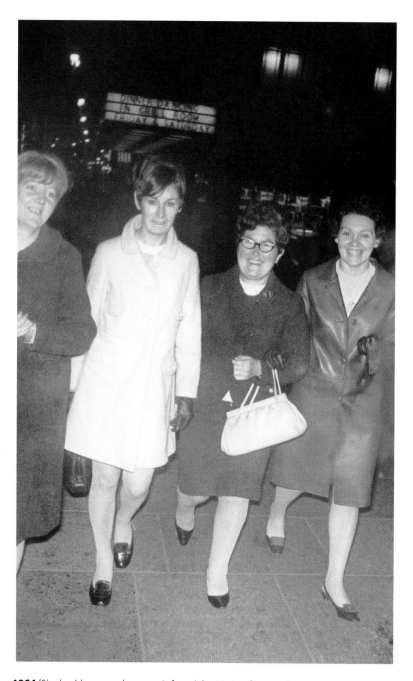

1964 'Single girls out on the town. Left to right: Marie O'Conner (née Mitten) RIP, Margaret McMenamin (née Kennedy), Marie Prince (née Ecock) and Betty Woods (née Whelan). They all worked together in the Castle Hosiery, Blackhall Place, Dublin 7. The photo was taken in 1964. They were on their way to the pictures at the Savoy on O'Connell Street. They always went to the pictures on a Wednesday night and to the Metropole (in the picture behind them) at the weekends. They went on holiday every year and travelled all over Europe together. Over fifty years later they still go out together for a meal every month and once a year they still go on holiday together.' *Deirdre Prince*

1964 'This is a photo of me (Sheila Dalton) and my mom (Mary Dalton). In 1957 my family had emigrated to Manitouwadge, Ontario, Canada, where I was born in 1959, the only Canadian in the family. My dad became terminally ill with cancer and died on 12 June 1964 at the young age of 38. Shortly afterwards, my mom brought all five of her children (I am the youngest) back to Dublin. I'm pretty sure this photo was taken in September 1964. I remember this day as if it was yesterday; I'm wearing my favourite outfit, a white dress with a light blue sailor-style coat and a little cherry motif on the collar. I remember feeling really embarrassed because so many people were looking at us getting our picture taken – I was so shy and felt so nervous. Everything in the city seemed so big after living in a small mining town in northern Ontario. This photo of my mom and me has always been my favourite. My mom was an incredibly strong woman; it wasn't easy for her to raise five children on her own in the 1960s, but she did a fabulous job and we made her proud! All these years later I am still amazed at the strength and courage she had bringing us up on her own. Gradually my family moved back to Canada in the late 1970s and settled in Vancouver. However, I only spent a short time there before moving back to Dublin to be with the love of my life.

'I didn't really know much about Arthur Fields back then, except that he was a man with a camera who was always taking photos. Myself and my husband have a few photos that were taken by Arthur. It was always a treat to have our photo taken, then we'd go in to pick them up, hoping they were good ones. We were never disappointed.' *Sheila Alwell*

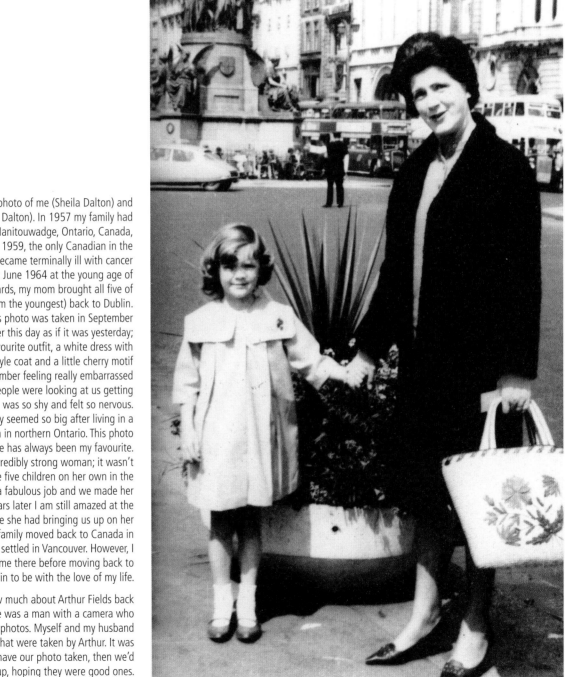

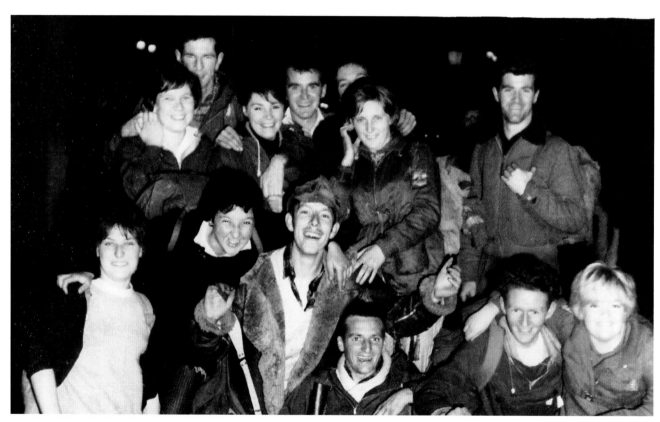

1964 'A group of hostellers returning from the youth hostel in Knockree after a weekend of hiking in the Wicklow Mountains. Far right at the back is myself, Jimmy Cushen from Larkfield Grove. We'd just got off the bus at Westmoreland Street, and the photograph was taken in the middle of O'Connell Bridge. The photo was taken in 1964. This group and others would regularly go hiking at weekends and stay in the An Óige hostels in Knockree, Glencree and Glendalough. During the summer months we would travel further afield to Kilkenny, Ballydavid and Mountain Lodge. The whole thing about meeting up at the hostels every weekend was the camaraderie. It was great fun – meet up, sing songs, laughter, the craic. Many of these hostels are no longer around but I'm still in An Óige. It's fantastic – people of today don't know what they're missing!' *James Cushen*

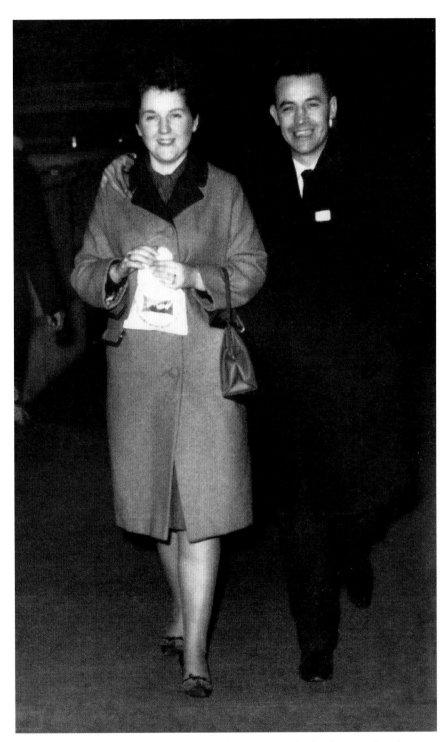

1964 'My granny, Maura Kavanagh, and my grandad, Seamus Roche. The photo must have been taken in 1964 or 1965 as my granny is wearing her engagement ring and they got married in 1965. She died from cancer in 1969, leaving my grandad and my mom (Vivian), who was three years old. My mom was put into an orphanage as my grandad couldn't handle life after the love of his life had gone. My grandad would visit her and take her out on day trips – he cared a lot for her, but he wasn't able to cope. He was the only grandparent I and my brother, Ivan, had, so for me he was very special and I could tell that my mom and grandad had a special bond. I treasured him. There aren't many photos of my grandad, so having this photo makes me so happy. I can feel their love and their happiness from their smiles.' *Esther Fah*

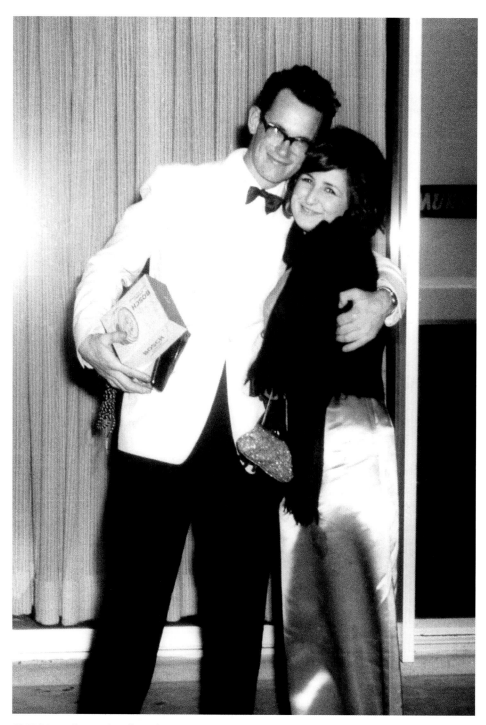

1964 'My mother, Marie Williams (née Hunt), with a friend, Peter Cunningham. This photo was was taken at 3.15 a.m. outside the ESB Dress Dance at the Intercontinental Hotel in Ballsbridge, Dublin 4 on Friday 13 November 1964. My mother won an electric toaster and a spot reversing light for a car.' *Annette O'Gorman*

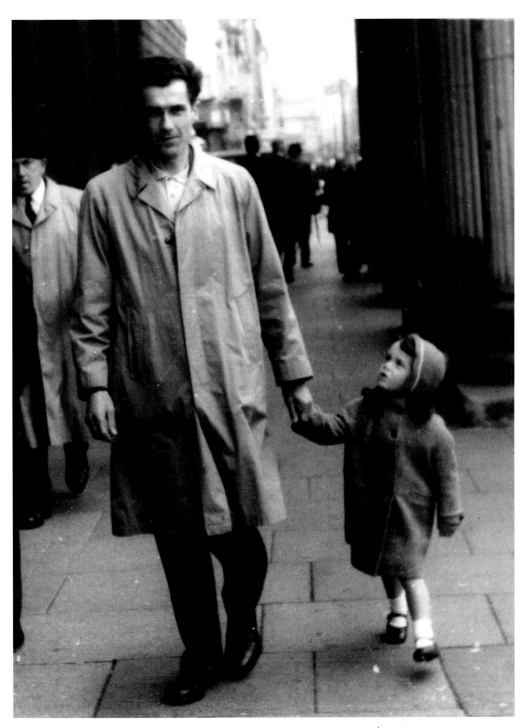

1964 'My dad, Sean Harkin, and me. He was originally from Leitrim and worked for CIÉ as a fireman when trains were fuelled by coal. In the late 1950s, when diesel engines were introduced, he was made redundant and got a job in Aer Lingus as a maintenance operative in the hangars. He met my mother, Joan McGibney from Inchicore, in Clerys Ballroom in Dublin and they settled on the north side of the city to be closer to the airport. I'm the eldest of seven children. I love the way I'm looking up at him as he looks at the camera. I treasure this photo and feel lucky to have it in my possession.' *Deirdre Flannelly*

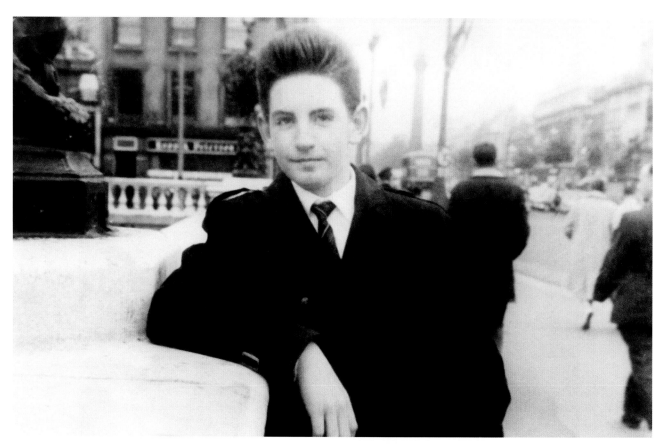

1964 'Myself, Paul Mullally, then of Comeragh Road, Drimnagh, Dublin. I was seventeen at the time and had just started a course in architectural technology in Bolton Street, sponsored by the Office of Public Works. I was paid four pounds, three shillings and tenpence per week in my first year, with all fees, books and equipment paid for by the OPW. My hairstyle at that time was in transition, growing out from a tight crew cut, common at that time, to a normal short, back and sides with a side parting. My hair needed to grow long enough before it would lie down.' *Paul Mullally*

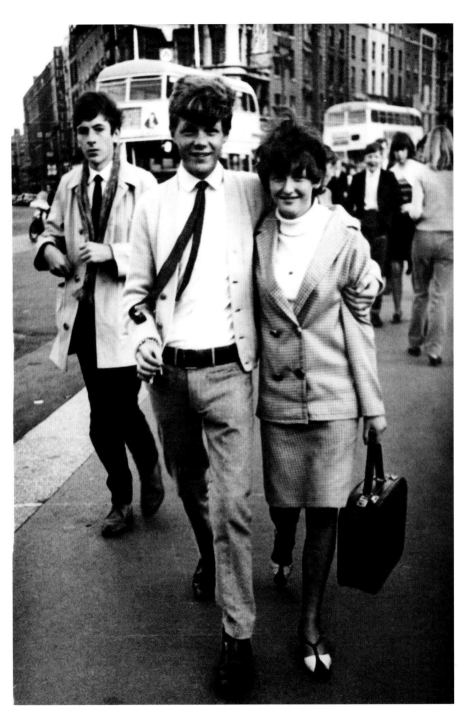

1965 'My uncle, Vincent Penrose (then fifteen), wearing a Slim Jim tie, and Joan Burke (then sixteen). Joan got on the number 42 bus at Seamount in Malahide and sat upstairs in the front seat. Vincent got on the same bus at Balgriffin (opposite Campion's pub). They were going into town to see Joan's brother Robbie, who was in the children's hospital in Harcourt Street (now closed). Joan's other brother, Christopher, is also in the photo (behind Joan's shoulder, wearing a white shirt and with his hands in his pockets). Vincent and Joan married in 1973 and went on to have three sons.' *Kerry Beggs*

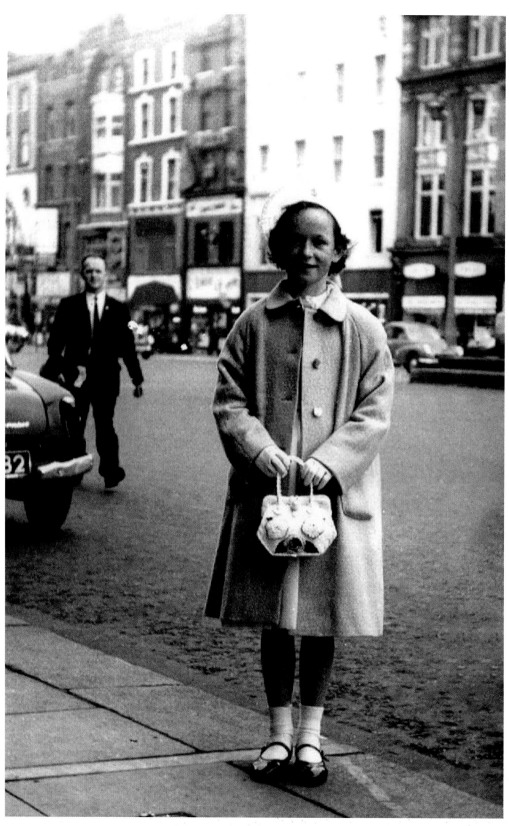

1965 'I had just made my confirmation, in St Peter and Paul's Church, Baldoyle, and I was going to visit my Aunt Sal in Dublin with my mam, Bridget, who is originally from the tenement houses next door to Bolton Street Tech.' *Pauline Mahony*

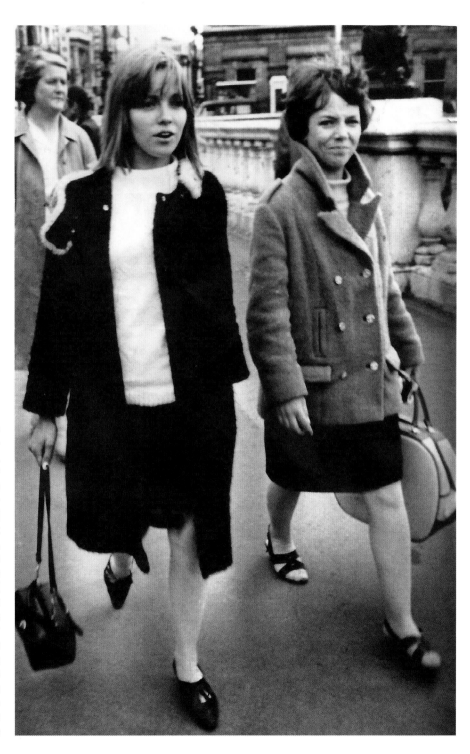

1965 'This photo of my friend Noeleen Byrne (right) and myself was taken in 1965 one Saturday on one of our weekly trips into town. We were on our way to shop in She Gear boutique, which was on the top floor of Roches Stores in Henry Street. This boutique was very popular with teenage girls at the time as it sold all the latest fashions, including Mary Quant black and white nail polish, which we loved. Sometimes we just browsed and listened to the music they played (all the latest hits). We were about fifteen at the time and weren't allowed into town at night. Taking the number 78 bus into town every Sunday to meet up with friends in Cafolla's café was one of the highlights of our week. Sometimes we went to Morosini-Whelan's in Henry Street to dance to a band called The Creatures. This was next door to Arnotts, where I worked as an apprentice carpet sewer. We also went to the Adelphi, Savoy or Capital cinemas to watch the latest films. This photo brings back so many good memories.' *Noeleen Baneham*

1965 'Carmel and me, Noel Newbury, on our honeymoon. Carmel was from Downpatrick and I was from England, and neither of us had been to the Republic before. We stayed in a hotel called the Ivanhoe somewhere around Harcourt Street. We loved our visit, and when the American company I was working for required a resident engineer in Dublin, I leapt at the chance to return to the city permanently. Amazing to reflect that in 1973 there were very few computer professionals in Dublin, which is why I transferred here. How things have changed! We stayed on in Cabinteely, which seemed a delightfully informal and friendly place. The tempo of life has accelerated in recent years, so I guess that makes me part of Dublin in the rare old times.' *Noel Newbury*

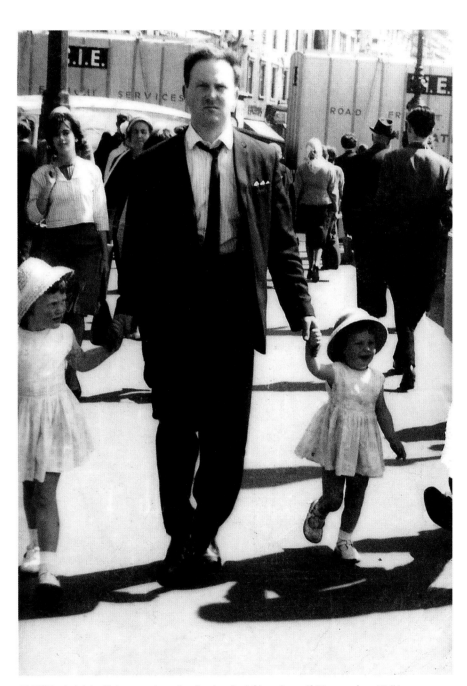

1965 'My dad, John Nolan, my sister Caroline (on the left), and myself. We were from Walkinstown. My dad was either a barman or on the boats at this point, and it was very rare that he got a day off so when we had quality time with him, we cherished it. He was a hard worker all his life and is still working hard. This is a photo I keep in my handbag and take it everywhere. *Adrienne Lynam*

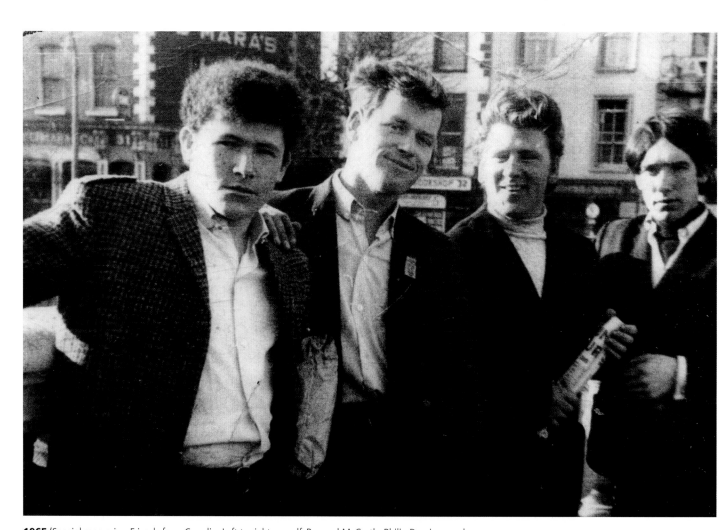

1965 'Special memories. Friends from Crumlin. Left to right: myself, Bernard McGrath, Philip Domican and Christy McCabe. Memories of days past.' *Peter Lynch*

1965 'Me and my fiancée, Hilary Franklin, in August 1965 crossing O'Connell Bridge on our way to Westland Row for pre-marriage instruction. It seems to have worked. We were married in Raheny a year later.' *John Halpin*

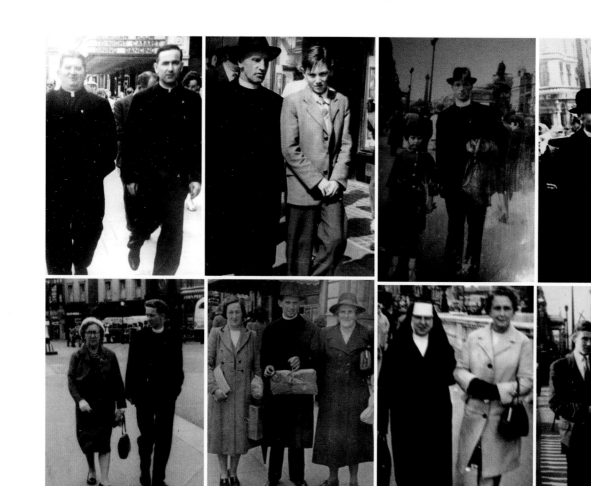

RELIGIOUS

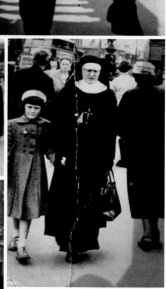

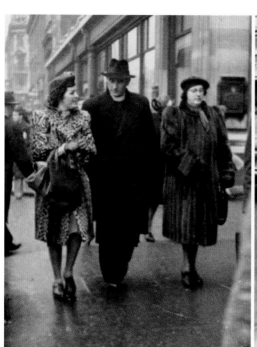

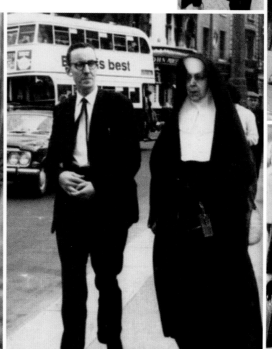

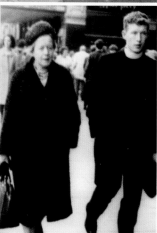

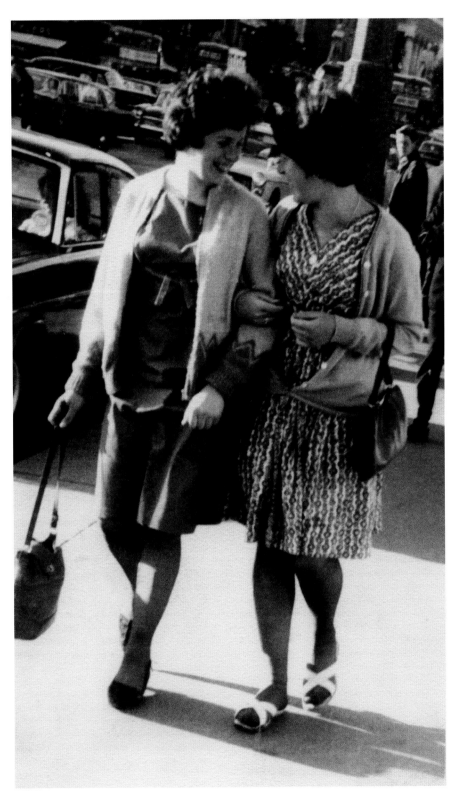

1965 'My sister Maura Sweeney (left) and her good friend and flatmate, Lilian McManus, both originally from Sligo, were enjoying a shopping day in Dublin city centre. When they spotted the photographer, Mr Fields, on O'Connell Street preparing to snap their photo, they locked arms and got the giggles.' *Edward Sweeney*

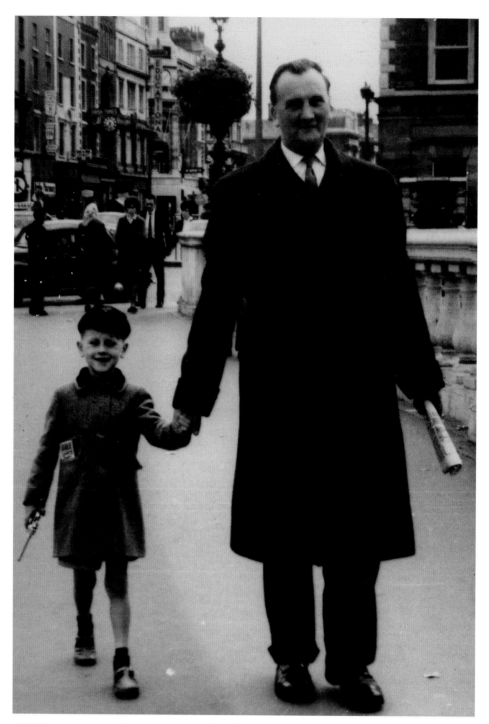

1965 'My dad, Sylvester Atkinson, and myself. My dad was employed with the Dublin Corporation (Marrowbone Lane) at the time and spent some years as a lamp lighter before becoming a lifebuoy attendant, cycling around Dublin's River Liffey to fix and replace lifebuoys. He used to bring me into town on Sundays, and this was taken around 1965. I'm wearing my school cap from St James CBS, Basin Lane, and that's a toy gun in my hand.' *Christopher Atkinson*

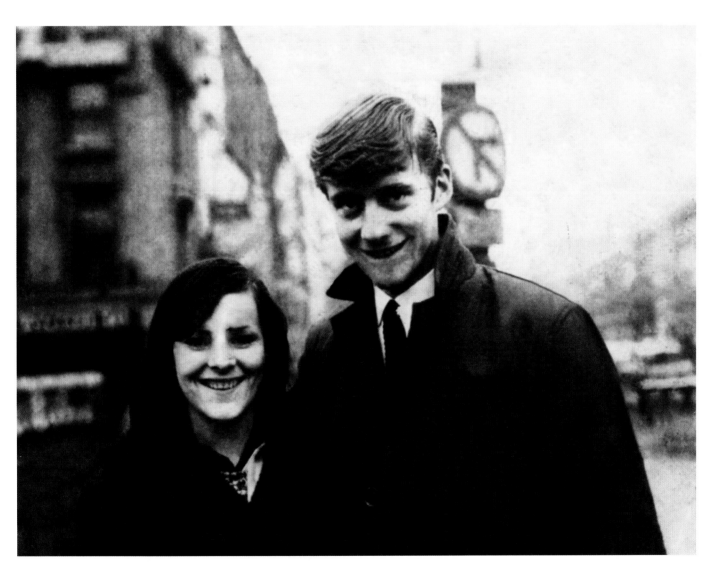

1966 'Christmas 1966. Myself and my future wife, Anne. It was the day of our engagement – a very joyous and happy day. Both of us worked in the Gateaux bakery in Finglas.' *Larry O'Toole*

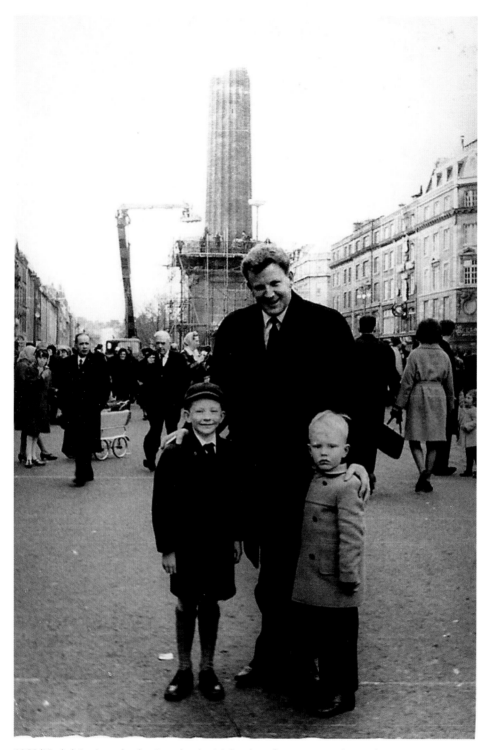

1966 'My dad, Denis, my brother Barry (on the right) and me, from Grove Road in Finglas East. We were dressed in our Sunday best, so I think the photo was taken on Sunday 13 March 1966. Nelson's Pillar had been blown up by Irish republicans on the Tuesday. Town was packed. Our mother was heavily pregnant with our younger brother at the time, so didn't come to town to witness the aftermath. In later years my dad explained that losing the pillar was a part of history. Looking back, it's great to have history captured in photos.' *Pat Murphy*

1966 'My mam and dad, Bridget and Vincent, in front of Nelson's Pillar in 1966. Dad had asked the Man on the Bridge to take the photo on that very spot!' *Lorraine Hughes*

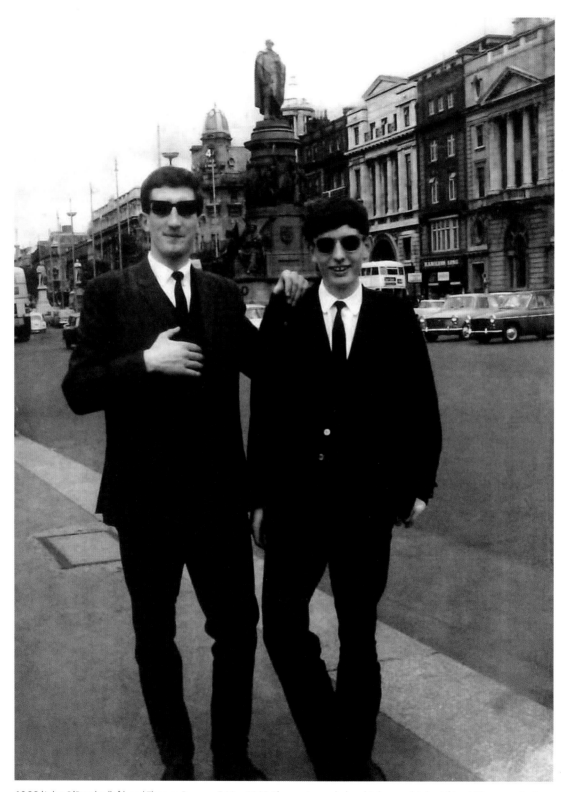

1966 'John O'Rourke (left) and Thomas Rooney, 5 May 1966. Thomas is my dad and John was his best friend. They were both from Cabra. Tom was eighteen at the time and John would have been nineteen. They regularly went into town to go to the pictures at the Adelphi cinema, more often than not followed by a dance at the CIÉ Club in Marlborough Street. They'd also have a nose at the remains of Nelson's Pillar as it had only recently been blown up. Back in the 1960s everyone dressed up to go out; they were freshly shaved, their shoes were shined and they always wore a shirt and tie!' *Niamh Rooney*

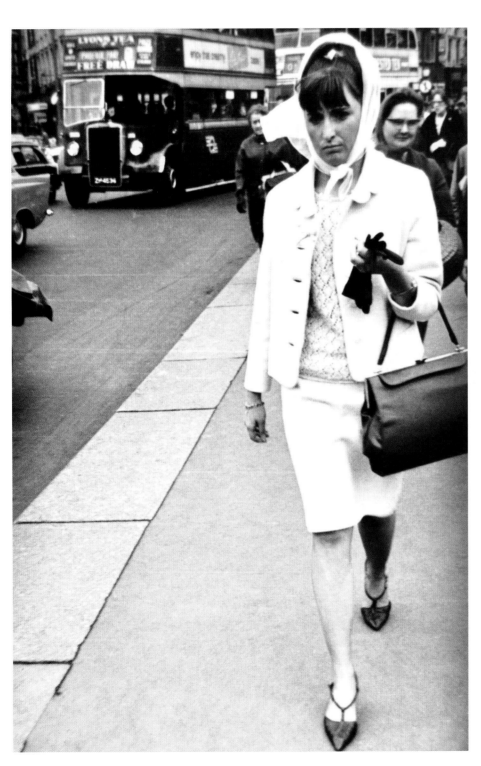

1967 'My fiancée, Patricia Burke. I met her purely by accident in Easter Week 1965. I was a member of the Dublin pop group The Blue Diamonds and we were playing a gig in St Anthony's Hall in aid of the Taxi Driver's Federation. We were married in 1969. Back then, I was always interested in photography and although I had a Box Brownie camera, the only informal photos you were likely to have as a couple were most likely those taken by the street photographers of the day. And if you were on a date in Dublin and you wanted a photo to share, you made sure to walk across O'Connell Bridge. I particularly love this image of Patricia taken on O'Connell Bridge as she made her way to meet me in July 1966. The photo has stood the test of time and makes a clear fashion statement of its day.' *Denis Tipple*

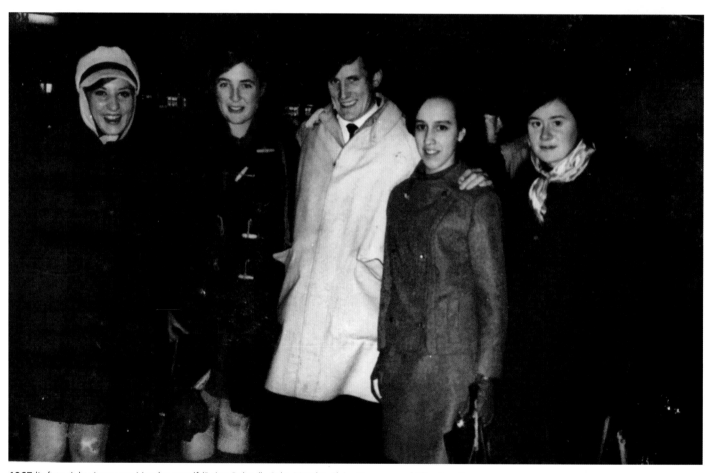

1967 'Left to right: Assumpta Murphy, myself (Bróna Boland), Colm Murphy, Claire Murnane and Alice Farrell, the staff of the brucellosis laboratory, Thorndale, Beaumont – now a housing estate. We were testing cows' blood for brucellosis. It was awful work, but it was very important.' *Bróna Uí Loing*

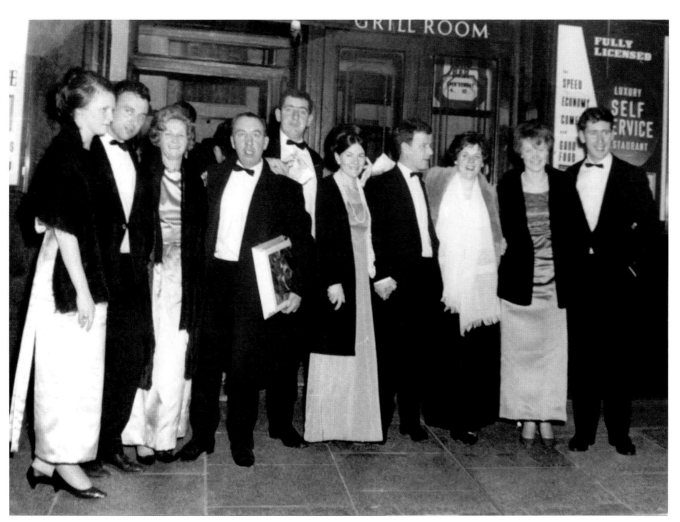

1967 'Pictured after the annual dinner dance at Glen Abbey, Belgard Road, Tallaght. Left to right: Jeanette Murphy O'Rourke, Tony O'Rourke, Mabel and Jimmy Duffy, Michael Walsh, Patricia and Johnny Campbell, Bernie Kealy Walsh, Margaret Dillon Walsh, and me, Sean Walsh. Old friends enjoying our night out. The dance was organised by the company and most companies at the time had formal-dress dances for their employees.' *Sean Walsh*

1967 'My dad, John Crampton (on the left), and his colleague Pat McGee, captured in 1967 on O'Connell Bridge, where they had many happy days controlling traffic. Pat was leaving his post on the day the picture was taken. At the time, there were no traffic lights on O'Connell Bridge.' *Edel Crampton*

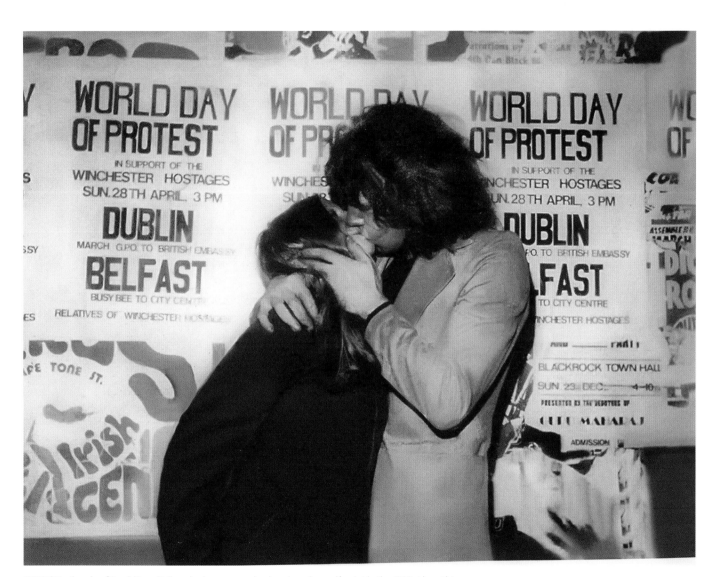

1968 'My then boyfriend, Tony Cully, who became my husband, and myself outside the GPO. I love this picture. When it was taken, we were young and in love. He remained a romantic throughout our 46-year marriage, and we were still madly in love until the day he died.' *Marie Cully*

1968 'Myself, Loretto Feeney, crossing O'Connell Bridge on the way to work in a jewellers' called Ring King in Grafton Street. I often got my picture taken by Arthur.' *Loretto McGarry*

1968 'When I look at this photograph, lots of memories come to mind. I was about seventeen or eighteen years old when this photo was taken in 1968 or 1969. I was attending ballroom dancing classes at Morosini-Whelan's of Henry Street at the time. I had succeeded in obtaining my bronze medal, which I still have, and was going forward in the hope of getting a silver medal. On that night, I had a dispute with my dancing partner about some dance movements. I think the pressure just got to me and I left early. I was doing a quick step home in the rain, still wearing my dancing sandals, when this photo was taken. The cross expression on my face had nothing to do with the photographer, rather this photo captures my annoyance at the events of that night.' *Mary Al-Rawi, née Moloney*

BASKETS

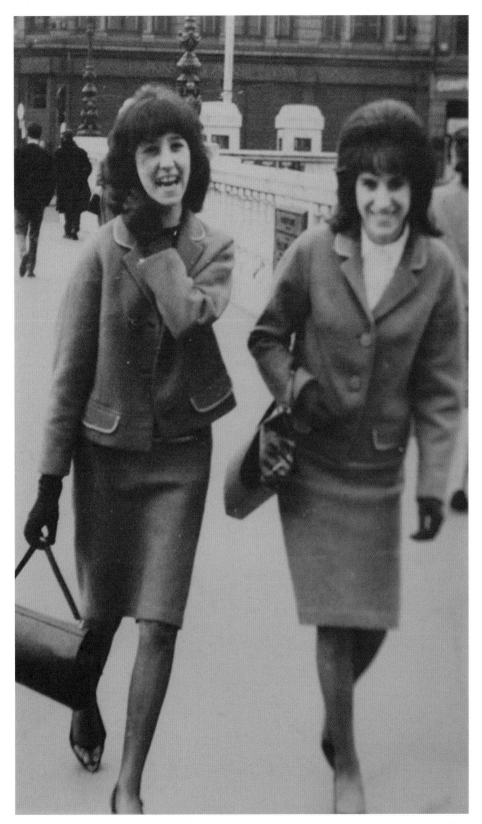

1968 'My mother, Rosina Pacini (on the right), with her sister Pellegrina. Both were born in Lucchio, a village in Italy, and moved here around 1960. The clothes they are wearing in the photo were bought for their first return visit to Italy, from which they had just returned.' *Claudia Darley*

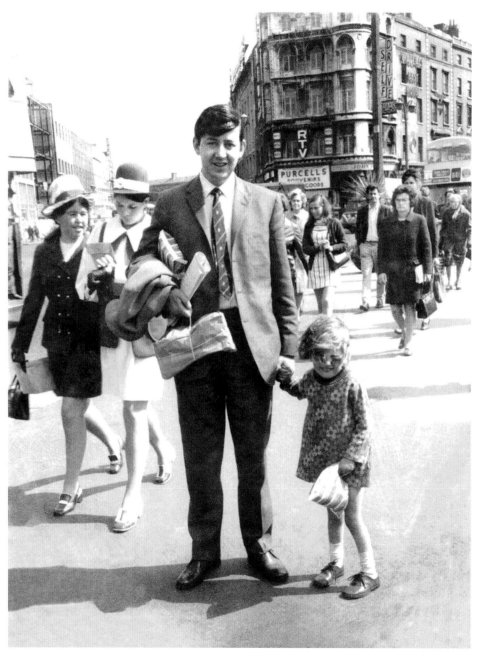

1968 'This photo brings back very special memories for me. I am the first-born in my family, and my dad, Gabriel McKeon, was a medical student when I was born. I was born with a dislocated hip and it was diagnosed late. As a result I had to spend time in Crumlin Hospital. When I was in hospital, Dad cheered me up by promising me that when I took my first steps he would bring me to the Man on the Bridge to have my photo taken. This then became a tradition for us to mark an event. Every summer when he was a student my dad would work in New York, and when he came home he would bring me to O'Connell Street. He would buy a new pair of shoes in Clerys (they're in the paper bag he's holding) and I would get a treat (in the Eason's bag). We would then have our photo taken by the Man on the Bridge. Shortly after the photo was taken, my family emigrated to England. I have come back to Ireland, but my mum and dad are still in England. This photo has a lot of history and is very close to my heart. I often looked at it in England and thought about my life in Ireland when I was little. It kept a memory alive for me.' *Edwina Mulcahy (née McKeon)*

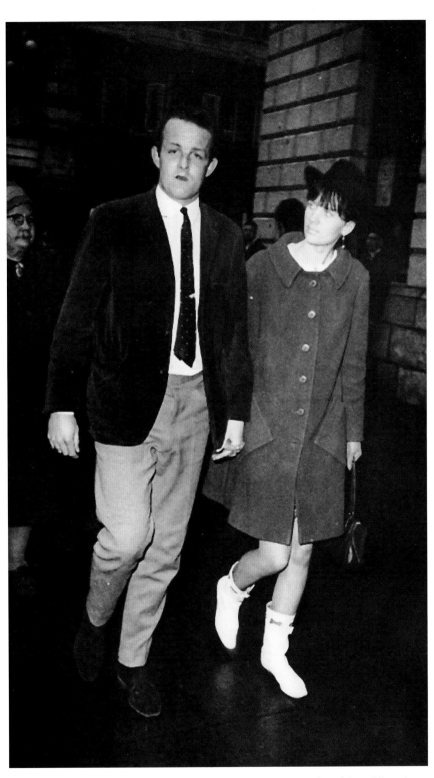

1969 'My mam and dad, Jimmy and Angela Keaveney. Jimmy was a member of the Dublin senior inter-county football team from 1965 until 1978 and is regarded as one of Dublin's greatest ever players, winning three All-Irelands.' *Roisin Hobbs*

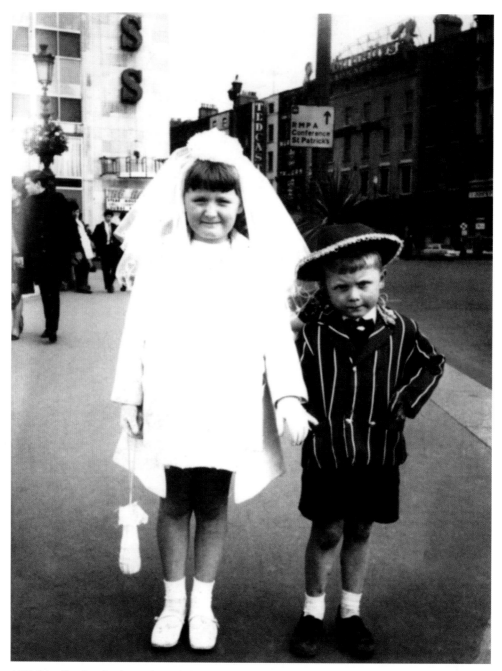

1969 'Myself and my brother Anthony Clarke on my first holy communion day, 3 May 1969. This is a Polaroid picture and we only had to wait one minute for it to develop. We lived in North Strand. I bought my brother that hat out of my communion money.' *Deirdre Coyne*

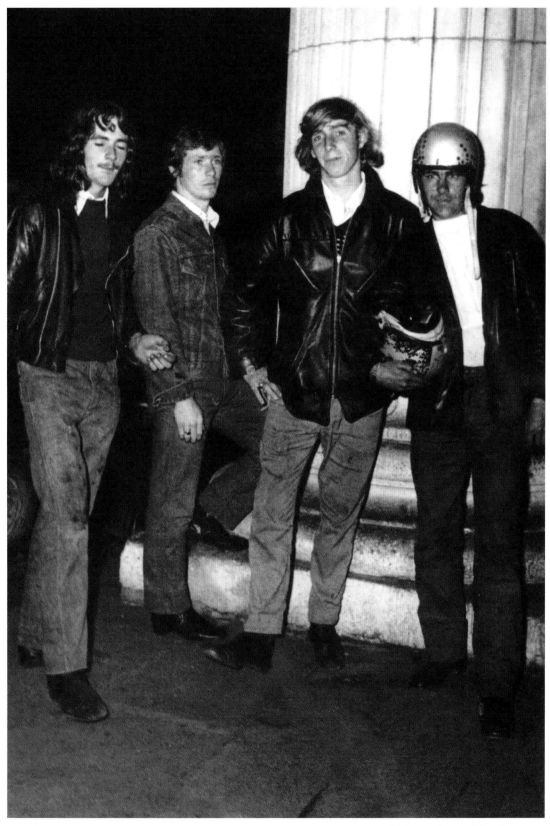

1969 'Brian Sullivan, Bill Byrne, Leslie Kirshaw and Brian Core, outside the GPO. We were all bikers and were all friends because we had motorbikes. I'm 64 now and drive a car.' *Brian Sullivan*

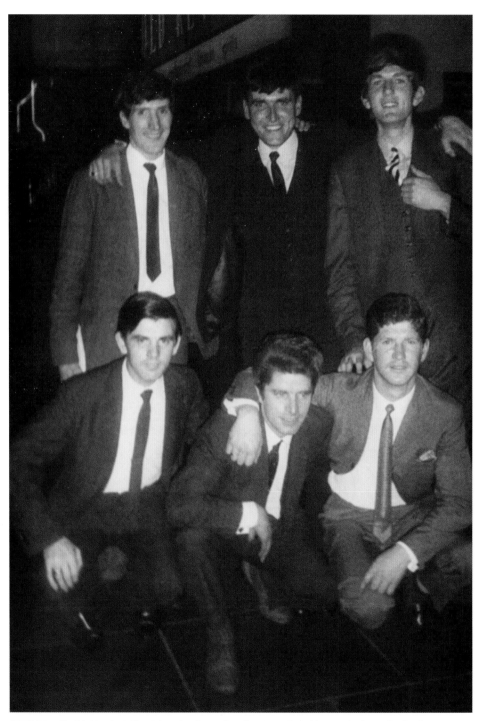

1970 'Myself with Martin Coffey, Edward Trainer, Edward Lucite, John Kildare and John Ball. After having drinks and craic (in sign language, as all of us were deaf) in the German Bar, Parliament Street, and finishing off with chips at the Rainbow Café, O'Connell Street, a photo was taken on O'Connell Bridge to grab the happy memories of us young men having a good time out in town, before dashing off to catch the last bus home back to lodging houses and bedsits.' *Henry Pollard*

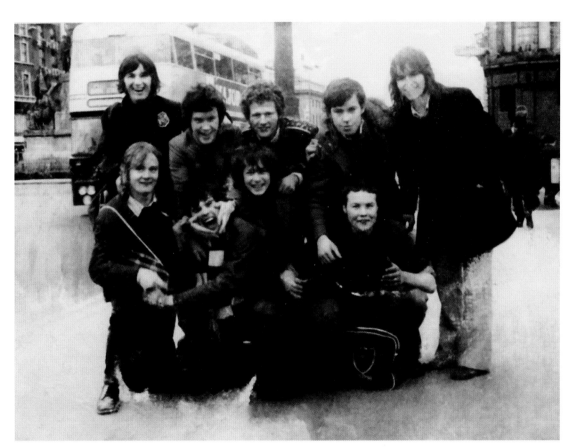

1970 'St Vincent's Football Club from Inchicore. Back row, from left: Gerry Coughlan, Killer Kelly, Git Quigley, Gerard Smith and Pat Armstrong. Front row, from left: Tom Fla, Joe O'Brien, Johnny Beer, Dicey Reilly. These were my teammates. We were a great team and won a lot of trophies and medals.' *Mick Peacock*

1971 'Myself and my then girlfriend, Eileen Mulrooney, soon to become Mr and Mrs Doyle. I went on to become a disability activist and was often seen protesting outside public buildings that did not provide access to wheelchair users and people with other forms of disability. This photograph is important to us because it's of its time; and because in the early 1970s it was a rarity to see someone in a wheelchair in a public place.' *Paddy and Eileen Doyle*

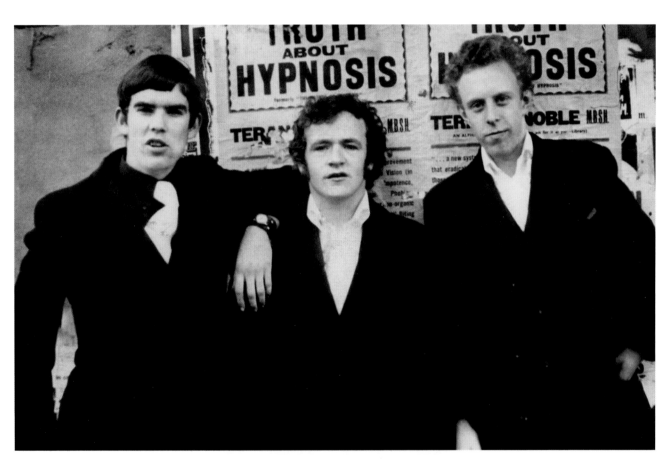

1971 'Joe O'Brien, Gene Cullen and myself. I was known as "cocker". I'm wearing a pinstripe suit and a Crombie coat. Joe must have thought he was in Goodfellas with his black shirt and white tie. We were only sixteen or seventeen and we used to go the Carlton Picture House. We might have looked like lads who were set to cause a bit of mischief, but we were harmless; dressed up to the nines and big into sport.' *Mick Peacock*

1971 'Me (on the left), Margaret Kilconnors and Peter Wynne. It was 1971 and I think we were all eighteen, just starting out in life after school, which for Peter and me was Synge Street; I don't know about Margaret. Margaret and I had met earlier that year on a train. We caught each other's eye as she passed along the aisle and we got talking. I think this was our first time out together. The major event in Ireland at the time was the outbreak of violence; 1971 was the year of internment and people were dying every day. Just four years earlier, we had all been wearing flowers in our hair for peace and love and everyone was either "California Dreaming" and wanting to go to San Francisco, or thinking of London and "Waterloo Sunset".

'Margaret and I only had a couple of dates, as unfortunately I had just discovered pubs. But over the years our paths have crossed on many occasions and we can have friendly banter about our brief liaison long, long ago, just as the shadow of the Troubles began to fall.' *John Moran*

1972 'Myself, then Chris Lennon, and my late husband, Des Keenan, on the day of our engagement. I had been working in Dublin and Des came up to town from rural County Longford. The one and only time he came to Dublin to visit me!' *Chris Keenan*

1973 'The Burke brothers from Ballyfermot: (left to right) Joseph, Patrick and me. We were very close growing up. My ma and da used to bring us into town every Sunday. We were always dressed the same and here we are wearing blazers. It was a regular occurence and the memories of these days together are precious to me.' *Michael Burke*

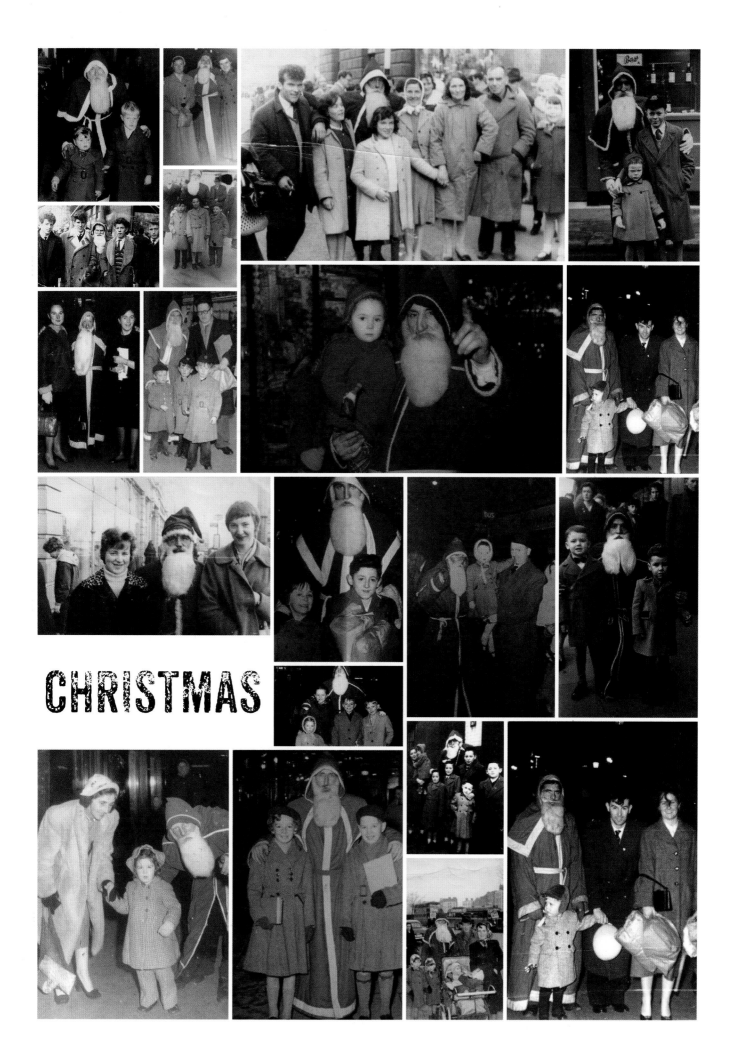

CHRISTMAS

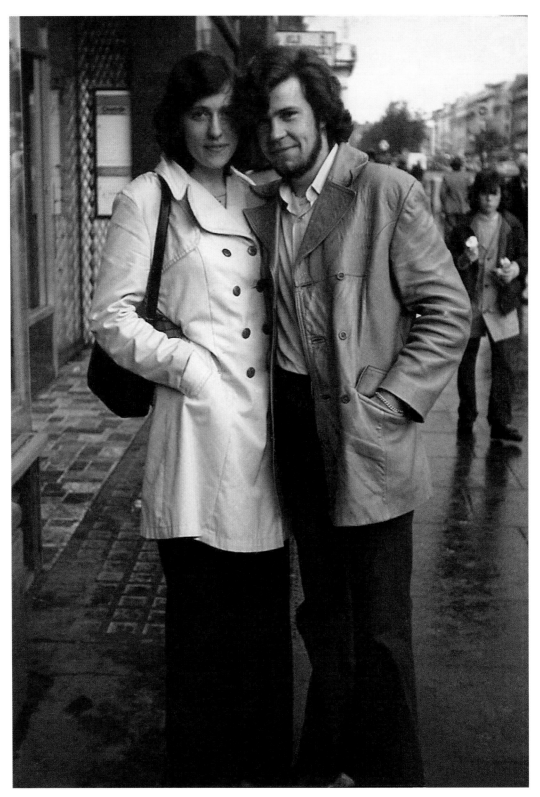

1974 'Tom McCormack and Dorothy Free. Tom and I were on one of our first dates when the man with the camera asked if we would like our photo taken. I worked in Westmoreland Street and remember often seeing him with his camera. Tom was from the southside and I was from the northside, so we always met in town. We were married in 1976.' *Dorothy McCormack*

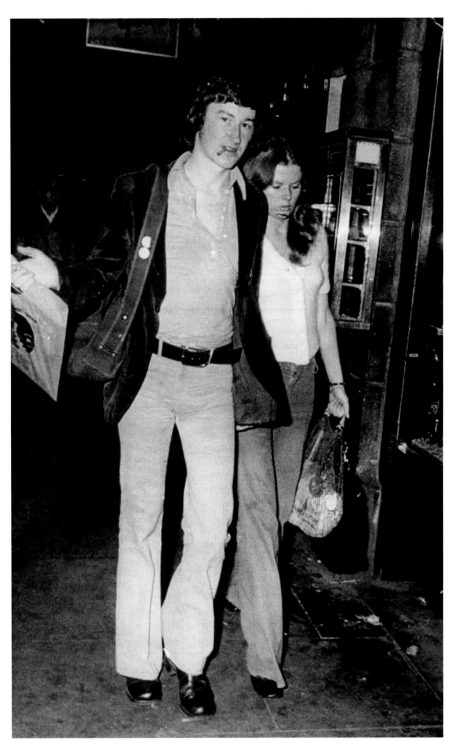

1974 'Myself and my fiancée, Christine Ryan. I'm smoking a Moroccan cheroot, which came wrapped in paper and in a triangular box. They were very cool at the time. The vinyl is probably an album by Weather Report, a jazz combo I was really into. I had spent some time in Switzerland and London so I thought I was extra-cool. My fiancée did window displays for a lot of shops in Dublin and London, which at the time was a big deal, and she was very talented at it.' *Sean Bradley*

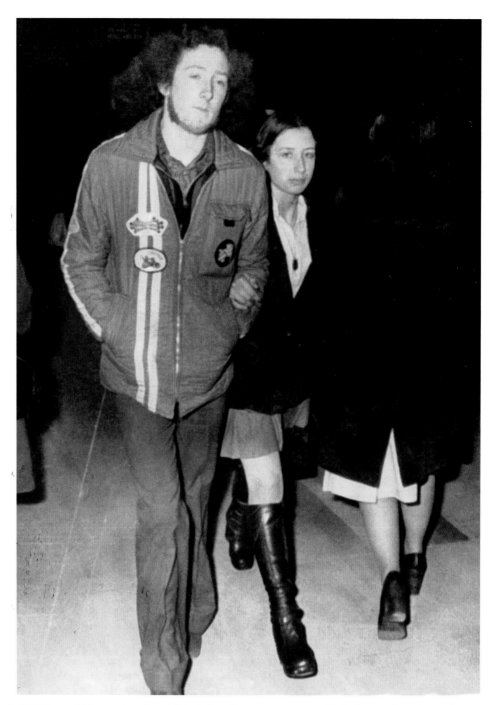

1974 'I was eighteen and my then girlfriend, Clare Byrne, was seventeen. We had been going out together since 1971 and eventually married in 1980. At that time, I lived on the High Road, Kilmainham and Clare lived in Islandbridge, so we spent lots of our weekend evenings going to the pictures in the city centre. We came across Arthur quite often. My abiding memory is of him wearing a couple of coats – presumably to keep warm – and his fedora-type hat, with his camera around his neck, doing his best to get to the throngs of people passing him. Some were oblivious to his always polite request to stop for a picture; some did stop, but mostly he would just click and hand you his card as you hurried past on your merry way. They were happy, carefree days in the 1970s, and remembering the Man on the Bridge brings those times flooding back – I suppose that's also his legacy.' *Stephen Kelly*

1975 'Olive Maguire and Gerard Ryan, my mam and dad, before they got married. This photo was taken in March 1975; they were both eighteen and they were shopping for his sister's wedding. It's important to me as my dad died three years later when he was only 21.' *Karen Ryan*

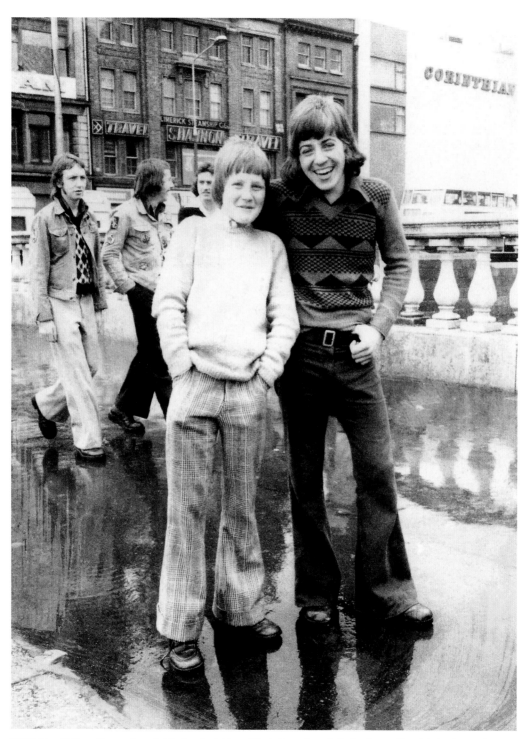

1975 'Myself, Gerry Dornan from Dublin (on the left), and Kevin Barry from Galbally, County Limerick. Kevin was from the same village as my cousins and they were up for the Spring Show, so myself and Kevin went for a wander around the damp city.' *Gerry Dornan*

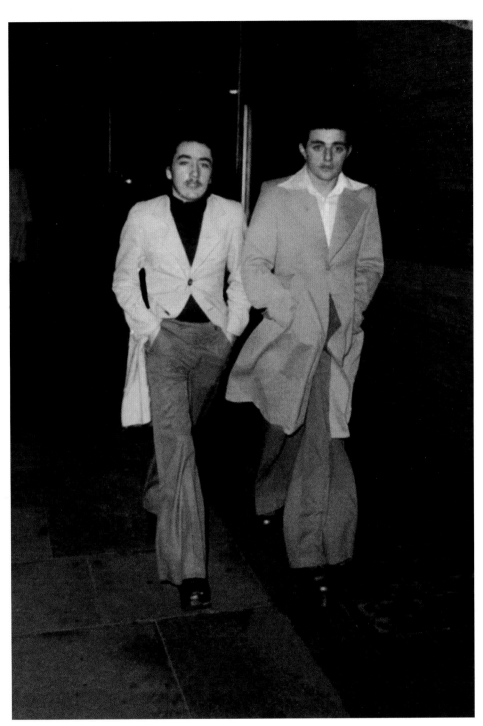

1975 'Brian Quinn (left) and myself, from Crumlin, walking across O'Connell Bridge in 1975. We used to get our suits made by a fellow on Thomas Street called Jas Fagan – he's still there. These "Showaddywaddy suits" were all the fashion.' *Willie Byrne*

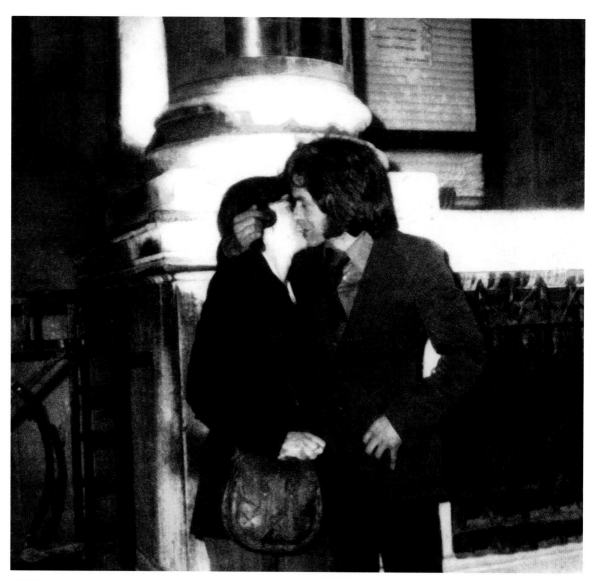

1976 'Myself and my then girlfriend, Helen Gavin. The photo was taken on O'Connell Street after a dance in the Irish Club. At that time, there were nine or ten dance halls in Dublin and in the Irish Club there'd be dances five or six nights a week. I have three other photos taken by Arthur Fields, all with different women. That was a trend of the time, taking a photo with a date. It was a fun thing to do.' *James Greally*

1976 'In this photo is a friend of mine, Larry, on the left, myself in the middle and my brother Tony on the right. It was the day that Dublin won the All-Ireland football final in 1976. The score was Dublin 3-8, Kerry 0-10. Kerry beat us in the 1975 final, so it was a grudge match and we were out on the rip. I've been a lifelong Dublin fan, going to Croke Park from 1957, and it was the usual mayhem that night. I think we ended up in Meaghars in Ballybough. Back then, you couldn't really buy any fan paraphernalia (flags, hats, scarves, etc.), so we made the horns we're holding and wrapped them in blue and white wool. We used to blow them on the Hill. The hats were butcher's hats that we picked up from Buckley's on Moore Street and we painted those as well. In 1978, we won the Best Flag on the Hill with a flag that said "Elvis is gone but the Dubs live on". Happy days.' *Martin Conroy*

1977 'Myself (on the left) and my friend Brian Howard. At the time, the two of us were fishing on the same vessel, the MFV *Brian Óg* out of Skerries Harbour. We were on the herring and this photo was taken after our first big pay cheque from a week's fishing. Herring fishing is a very adrenaline-filled pursuit; you have to spot it, chase it and catch it. It's also very competitive, and after this big catch, we felt on top of the world. We were only seventeen and we headed into town to spend a few bob and buy a bit of gear. We fished together on and off for the next twenty years or so.' *Dominic Orange*

1979 'My late brother, Joseph Mahon from Cabra West, and his then girlfriend, Mary Kendrick. He tragically died a few months later following a motorcycle accident. He looks a lot older, but he was just eighteen at the time and he had finished school a few months before this photograph. This is the last image taken of him before he died and it's really important in our family, especially now that there are nieces, nephews and grandchildren he never met.' *Cathy Molloy*

1979 'The photo was taken about 1979, late evening. (From left) Brendan Duggan, Willie Carey and I were carrying out a shop refit for Manning's bakery in Talbot Street, which took a few all-nighters to complete.'
Charlie Lyons

1979 'Myself (left) and Tom Hartley, coming from the Sinn Féin ard fheis and looking very conspiratorial! This picture was taken in O'Connell Street, near the bridge. Both of us are now authors and Tom later became Mayor of Belfast.' *Danny Morrison*

1979 'Me with my first girlfriend, Sylvia, on O'Connell Street. We broke up a few years after this photograph and didn't see each other for 34 years. We have now been back together for over two years. Good things come to those who wait!' *Jerry Clare*

1980 'Myself, then Nuala Carr, from Bray and Patsy Lacey, my boyfriend, also from Bray. We were on our way to the Cappagh Hospital to see a friend of ours and Patsy's holding a basket of fruit. Only a couple of years later, just before we were set to marry, Patsy was knocked down and killed on the footpath in Ballybrack by a drunk driver. Patsy was only 21. This photo means so much to me as there just weren't that many photos taken back then. I am married now, but we are still very close to Patsy's family.' *Nuala Doyle*

1982 'This photo of my husband, Richard White, and our daughter Myra was taken in 1982. I was a patient in St Vincent's Hospital, Elm Park, at the time and they were on their way from Heuston Station after travelling up from Tullamore, County Offaly, to visit me. It's funny – I remember giving out to him about the way he dressed her on the day, saying to him, "The poor child, if anyone sees her." I guess he never thought this picture would appear in a book!' *Dymphna White*

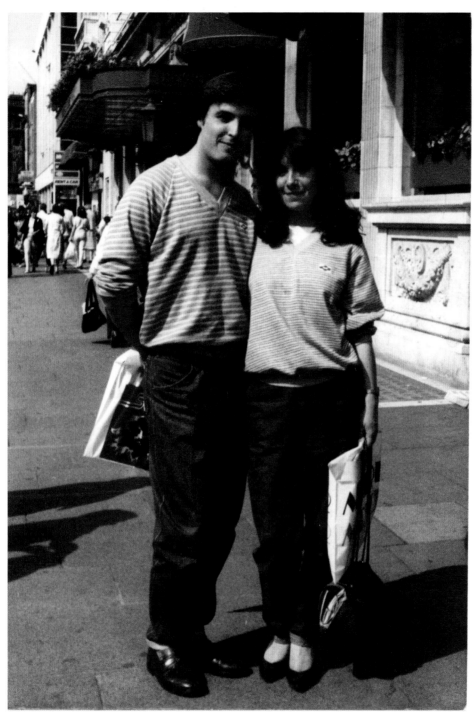

1982 'Me and my girlfriend, Annette Kelly, shortly before our engagement. It was on a Saturday afternoon and we were shopping for an engagement ring (after visiting a dozen jewellers, we found the one she wanted). I worked in Glenabbey, Patrick Street, at the time, and that's where I made our matching sweatshirts. I remember Arthur from way back, when I was a youngster. On Sunday evenings in the summer when I would be coming home with my parents from the "Mystery Train" trips, we'd see Arthur on the bridge or further up O'Connell Street. Great memories.' *Noel Fitzgerald*

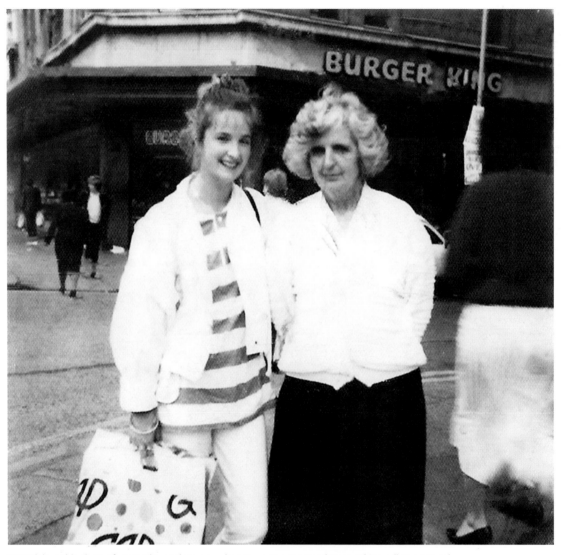

1986 'I love this photo of my mother and me on a shopping spree. It was taken on O'Connell Street in July 1986, and I was working on the B&I while I was in college, so I had money to spend. My mother had had her photo taken by Mr Field when she was younger, and remembered him fondly as a great Dublin character. Time has taken its toll on my mother, and she has dementia now, so it is lovely to see her so pretty, young and happy looking.' *Michele Cashman*

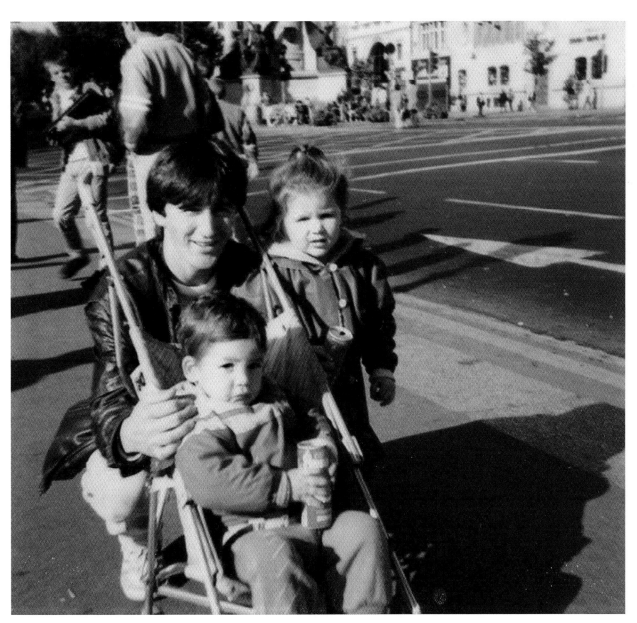

1986 'This picture was taken in the summer of 1986. My daughter Carly was three years old; my nephew Gary Carbery was two years old; and I was 26.' *Thomas Walker*

1988 'Myself and my wife, Sandra. This photo must have been taken at the very end of Arthur's career. We still have it safe, wallpaper frame and all. I also have a photo taken by him of my grandparents in the 1950s.' *Paul Roy*

'I took this photo in 1978 when I was a budding photographer. I was seventeen at the time and working in a photo lab in Harolds Cross as well as wandering the streets of Dublin taking photographs. I remember seeing Arthur on O'Connell Bridge at the time. I was home in Ireland recently (I now live in Australia) and saw the documentary about him on TV. What an amazing story. This is one of a number of pics I took of Arthur.' *Michael Cusack*

ACKNOWLEDGEMENTS

Trend images courtesy of: Anita Grant Plunkett, Graham Coffey, Joyce Denver, Glenda Daly, Orla Monks, Liz Hannon, Kim Ross, Tom Coakley, Mary Curran, Martina Skelly, Karen Foley, Ann Burns, Colm Murphy, Bernie Dalton, Liz Coffey, Josie Kerr, Una Kelly, Ronan Henderson, Judy Maguire, Trudy Smith, Regina Richardson, Vera Abbott, Gabrielle Deans, Frances Melia, Charles Johnston, Mary Wall, Helen Regan, Paula Hayden, Fiona Lawlor, Peter O'Neill, Brendan Tormey, Karren Hopkins, Sean Francis Byrne, Anita Grant Plunkett, Margaret McKiernan, Regina Donoghue, Sally O'Sullivan, Gerard Griffin, Denise Dunphy, Felednia O'Meara, Dara Blake, Jim Casey, Brigid Mulvany, Anna Bracken, Sandra Moran, Carmel Corcoran, Mary Richards, Louise Gillick, Dara Blake, Gerard Griffin, Marie Dunne, Marion Gerety, Evelyn Halpin, Emer Kenny, Eleanor Hegarty, Anita Morrisey, Letty Byrne, Ann Hayes, Tom Mc Manus, Barry O'Neill, Margaret Sanders, Paddy Kelly , Jackie Harrington, Bernice Wheatley, Audrey Dooley, Georgina Kelly, Mary McSharry, Deirdre Purcell, Miriam Dunne Cheatle, Thomas Courtney, Noreen Dowling, Rita Martin, John Barrett, Andy Dalton, Theresa Hannan, Rhonda McGlue, Tony Murnaghan, Derval Lundy, Stella O'Neill, Joe Devlin, Yvonne Lawless, Mark O'Keeffe, Fred Heatly, Eamon Martin, Mary Richards, Charlie Martin, Vivian Quinn, Eddie Walsh, Ken Harrington, Brigid Mulvany, Michael Murray, Marian Burke, Marion McCarthy, Marian Beggs, Phyllis O'Connor, Maria Gibson, Yvonne Walsh, Carol Callaghan, Mary Wall, Eileen Killeen, John Toner, Bernard Walsh, Anita Morrisey Oconnor, Elizabeth Egan, Joan Martin, Gerry Adamson, Mary McGowan, Marguerite Curran, Dermot Byrne, Penny Delmar, Paula Hanley, Myra Mangan, Ruairi Boyce, Dave Maher, Mary McGowan, Catherine Murtagh, John Feltus, John O'Hanlon, Toddlers, Sandra O'Hara, Derek Long, Linda Weekes, Geraldine Birtles, Bernard Walsh, Lauren Boon, Kate O'Raghallaigh, Derek Warfield, Denise Roe, Patricia Morris, Mick Cullen, Mary Ashe, Michaelle Dunn, Bea O'Neill, Sinead Curry, Ken Harrington, Susan Courtenay, Jackie Fitzgerald, Peter Wilson, Noreen Byrne, Stephen Maughan, Florence McElroy, Jacky Preston, Theresa Hannan, Mary Richards, Patrisha Lovelle, Helen Moran, Oliver Mills, Annette Owens, Michael Duffy, Peggy Brehony , Barry Doyle, Cathy Flynn-Byrne , Rita Leatham, Pamela Cox, Bernadette Cambell, Andy Dalton, Patrick Doyle, Frank Nolan, Linda Weekes, Will Hamilton, Margaret Smith, Jim McDonald, John Murphy, John Quigley, Catherine McGrath, Frank O'Donnell, Phyllis O'Connor, Eileen Howley, Diarmaid McGuinness, Barry Doyle, Patrick Banks, Declan Colagn, Louise Hipwell, Lorraine Devereux , Lynda Fitzgerald, Fleurette Dixon, Teresa Keane, Frances Melia, Sheila Sheridan, Carmel Tobin, Margie Philips, Sally Dunleavy, Micheál Hughes.

Special thanks to: the family of Arthur Fields, Anne & John Deeney, Margaret & Brendan Clarke, Orla Fitzpatrick, Garry O'Neill, Niall McCormack, Martin Mooney, Brian Whelan, Brian Murphy, Trish Lambe, Tanya Kiang, Berminghams Cameras, Gunne Cameras, Sarah Ryder, Colm Quinn, Liam O'Cathasaigh, Eibhlin Roach, Hitone Books, Anne-Marie Kelly, Gavin Halpin, David Davison, the Irish Professional Photographers Association, Trish Brennan, Deirdre Laird, Natalie Christie, FujiFilm, Jackie Farrell, Grehan Printers, Karen Ruddock, Sarah Dillon, Kevin Denny, David Denny, Ballymun Stevo, Laura Bergin, Ruarí O'Cuiv, Ray Yeates, Clerys, Angela Smith, Dave Leahy, Sybil Cope, Angela Scanlon, Chris O'Dowd, Ben Readman, Róise Goan, Cllr. Christy Burke, Block-T Dark Room, Anthony McGuinness, John Curran, Mella Travers, Peter Kavanagh, Active Retirement Ireland, Dublin Ghost Signs, Age Action, Ryan Tubridy, Elayne Devlin, Róisín O'Dea, *The Late Late Show*, Denise Dunphy, The Factory, In the Company of Huskies, Martin Busch, Scanners.ie, Epson Ireland, Derek Cullen, Colin Lawlor, Business To Arts, Andrew Hetherington, Designist, DIT Media Department.

First published in 2017 by
The Collins Press
West Link Park
Doughcloyne
Wilton
Cork
T12 N5EF
Ireland

A CIP record for this book is available from the British Library.

Hardback ISBN: 978-1-84889-332-0

Design and typesetting by Glen McArdle
Typeset in Frutiger and Myriad Pro
Printed in Poland by Białostockie Zakłady Graficzne SA

Cover images
Front and spine: Arthur Fields on O'Connell Street, Dublin, in the 1980s. (Courtesy of Sergio Seghetti)
Back, clockwise from top left: Nuala Doyle (née Carr) and Patsy Lacey, her then boyfriend, in 1980; Tony Connolly *(left)* and Tony Byrne, both members of the FCA, after the Easter Military Parade in 1962; Christy Clifford, in 1946; Gerry Dornan from Dublin and Kevin Barry from Galbally, County Limerick, in 1975; Paul Roy and his wife Sandra in 1988; Thomas Walker with his daughter Carly and nephew Gary Carbery in the summer of 1986; David *(left)* and Patrick English in 1963, when rock and roll music was just coming on to the scene.